IMAGES
of America

# LeSourdsville Lake and Americana Amusement Park

ON THE COVER: What began as a recreational park for swimming and picnicking in 1922 quickly became one of the country's favorite traditional amusement parks for decades. The sandy beach and diving platforms were a favorite among guests young and old. The beach was eventually replaced by a modern Olympic-size swimming pool, but the memories live on. (Monroe Historical Society.)

IMAGES
*of America*

# LeSourdsville Lake and Americana Amusement Park

Scott E. Fowler
Foreword by William H. Robinson

ARCADIA
PUBLISHING

Copyright © 2022 by Scott E. Fowler
ISBN 978-1-4671-0838-6
ISBN 978-1-5402-5237-1
Published by Arcadia Publishing
Charleston, South Carolina

Library of Congress Control Number: 2022932944

For all general information, please contact Arcadia Publishing:
Telephone 843-853-2070
Fax 843-853-0044
E-mail sales@arcadiapublishing.com
For customer service and orders:
Toll-Free 1-888-313-2665

Visit us on the Internet at www.arcadiapublishing.com

*In memory of Edgar and Ernest Streifthau, Bill Rothfuss, Don and Dorothy Dazey, Frank Murru, Bill Barr, Mary Ann and Howard Berni, and Ronald Walker.*

# Contents

| | | |
|---|---|---|
| Foreword | | 6 |
| Acknowledgments | | 7 |
| Introduction | | 8 |
| 1. | Park Emerges as a Favorite | 9 |
| 2. | A Survivor of Major Changes | 29 |
| 3. | Ownership Shifts Shape the Future | 65 |
| 4. | New Owners Close Park | 71 |
| 5. | Park Emerges as a Memory | 83 |
| 6. | The Transformation Begins | 91 |
| 7. | LeSourdsville Arises | 111 |

# Foreword

After the 20-plus years I spent working at LeSourdsville Lake/Americana, I think of all the great memories that millions of families must have from visiting the park over its long history.

For me, the knowledge I received of the amusement industry working for and with park owners Howard and Mary Ann Berni was an education I could have never received anywhere else.

The Berni family had a great management team who taught me every aspect of the amusement park business, from John Berni, Howard's father who owned and managed the arcade; Dorothy Dazey, who sold the park to the Bernis and managed the office; Lou Faggionato, who owned and managed the games; Frank Silvani, the food service manager; Cecil Grubbs, the head of ride maintenance; and Bill Barr, who taught me group sales and marketing.

I also think of the thousands of young students who worked at the park. For many of them, like the author of this book, it was their first job. It did not make any difference if they ran a ride, worked in food service, conducted games, or cleaned the park, they learned and did their jobs, and that is what helped to make the park special.

Today, my son John and I and Howard and Mary Ann Berni's son Ron and his son Beau still work in the amusement industry, passing on and teaching others the Berni brand of fun!

—William H. "Bill" Robinson
Vice President, LeSourdsville Lake/Americana, 1962–1983
President, William H. Robinson Inc. (WHR Inc.), 1983–present

# Acknowledgments

Thanks to Jim Ewen, Tom Rhein, and Alfred Freeman for their contributions of stories and photographs. Jim worked at LeSourdsville during the same years I did, but we never crossed paths until years later thanks to Facebook. Tom was vice president during the Coney years and was always finding relics to share. Alfred was one of the Screechin' Eagle operators back in the 1970s and knew every bolt and board in that legendary coaster.

My LeSourdsville coworkers, including Else Kesterman, Becky Mainous, Linda Meyer, Daren Slonecker, Bob Sick, Kitty Frey, Debbie Berni, Paul Gartman, Chelle Mann, Pam Abner, Dee Crabtree, Cindy Minor, Nancy Heet, Kathy Abner, Italian Gina, Kim Rudd, Gary Fraley, Mike Cameron, Richard Butterfield, Lois Woike, Nancy Lewis, Renee Fletcher, Kathy Dysert, Melanie Howe, Renee Whitest, Gary Fugitt, Darlene Breedlove, Lenny Silvani, Wayne Back, Teresa Herlihy, and "Bubble Gum" Bob provided inspiration whether they realized it or not.

My LeSourdsville managers, including Frank Silvani, Vicki and Ron Berni, Howard and Mary Ann Berni, and Guy "Super Thick Shake" and Diane Sutton, somehow shaped my positive work ethic. They all aged prematurely during my tenure.

Special thanks to Jacquelyn and Josh Van Lieu, owners of the Fantasy Diner and Ice Cream Parlor, located on the grounds of former Fantasy Farm Amusement Park, next door to LeSourdsville, for donating 100 percent of the proceeds from sales of the first LeSourdsville Lake book and the Fantasy Farm book to the Monroe Historical Society to help establish a museum on the grounds of LeSourdsville.

Thanks to former LeSourdsville Lake vice president William "Bill" Robinson, who held the very first book signing of my first LeSourdsville book at his store, John Robinson Mercantile, located at Trader's World in Monroe, Ohio, and to Bill's wife, Dianne, who assisted in providing many of the photographs from the late 1970s and early 1980s.

Thanks to my Arcadia Publishing editor Caroline Vickerson for her input and for keeping me on track.

# Introduction

In 2011, the first edition of Images of America: *LeSourdsville Lake* was released, and the reaction of most readers was the same: "LeSourdsville Lake was the best place I remember as a kid." The story continues with this edition with a deeper focus on the changes in the last 50-plus years. Another way to look at it is that there is now a generation of people who did not experience LeSourdsville Lake/Americana, which is unfortunate.

There is a generation of people who do not realize that LeSourdsville Lake started out as a recreational park. It took a major fire and a newly formed friendship to help turn the corner and transform into a full-fledged amusement park.

There is a generation of people who do not realize that LeSourdsville Lake and Fantasy Farm were developed by the same person, Edgar Streifthau. It was not until both parks had gone out of business that the two properties fell under one person again. There are several reasons why LeSourdsville Lake/Americana and Fantasy Farm did not consider a merger and it was unfortunate that people could not have united and put their differences aside.

There is a generation of people who believe that the opening of Kings Island in 1972 forced LeSourdsville Lake/Americana to close. Nothing could be further from the truth. Before Kings Island, Coney Island served as the park's major competitor. LeSourdsville Lake survived for 30 years after Kings Island opened before plummeting due to poor management and ownership that did not have the income to bring in new rides and attractions.

That same generation does not realize the number of wedding proposals, first dates, first jobs, family reunions, high school after-proms, first concerts, first roller coaster rides, roller-coaster riding records, lake drownings, and some stories that should stay in LeSourdsville Lake that took place over the 70 years the park operated.

There is a generation of people who do not realize that Coney Island threatened to permanently close LeSourdsville Lake/Americana if they could not sell the park in 2000 to a noncompeting amusement park company. Instead, Jerry Couch took the fall after the management company he hired to run the park could not turn a profit and went bankrupt before the season ended.

There is a generation of people who will never have the chance to leave their children to experience the park themselves and return safe and sound, or to not stand in line for long periods of time waiting on their favorite rides.

There is a generation of people who are not sure whether to call the park LeSourdsville Lake or Americana. There is a generation of people who only know the park by Americana. This book refers to the park as Americana only when documenting the years 1978–1999, when the Americana name was used. As owner Howard Berni said bluntly in a 1978 *Hamilton Journal-News* interview, "It wasn't that there was anything wrong with the name LeSourdsville, it just wasn't a name that stayed in your mind, and nobody could spell it."

There is a generation of people who were too young to visit LeSourdsville Lake/Americana, but will still want to read about its history and then get excited to read more about the park.

# *One*
# PARK EMERGES AS A FAVORITE

The popularity of Woodsdale Island Park, Butler County's first recreational area, paved the way for LeSourdsville Lake to survive in the middle of nowhere on State Route 4 north of Hamilton. Woodsdale was located on a 34-acre island between the Great Miami River and the Miami-Erie Canal just south of LeSourdsville and opened in 1892. Woodsdale was constructed by the Cincinnati, Hamilton, Dayton Railroad Company to boost its business on the weekends. Due to the park's location along the river, it was often a victim of flooding. Woodsdale was finally closed in 1908 after the canal was drained.

In 1922, Edgar Streifthau, a resident of Lemon Township, just a few miles from Woodsdale, was seeking a place to offer swimming. Streifthau recalled his boyhood and remembered the ice blocks that were stored next to the Miami-Erie Canal in the village of LeSourdsville. He leased the land that used to be a lake to create ice blocks and dug out the old lake with a team of horses. Ernest Streifthau, Edgar's brother, became a partner and they opened LeSourdsville Lake on May 8, 1922. Business flourished to the point where the bathhouse had to be enlarged three times the first summer.

In 1934, just prior to the park opening for the summer, an accidental fire destroyed the bathhouse. Streifthau rushed to get the building rebuilt and met Don Dazey, an architect from the Middletown Lumber Company. Dazey was offered a partnership and became the park manager. Dazey added a carousel to the recreational park, and the popularity soared. He then added more mechanical rides, and by World War II, the amusement park was born.

Dazey also developed a group outing concept that enabled large and small companies to offer picnics to their employees as an employment benefit. On July 4, 1947, the park hosted 30,168 people, the largest crowd ever to enter the gates.

In June 1959, Don Dazey died, and a local bank wanted to recall a loan used to upgrade the park. LeSourdsville Lake was sold to Cedar Point concessionaires Howard Berni and Frank Murru.

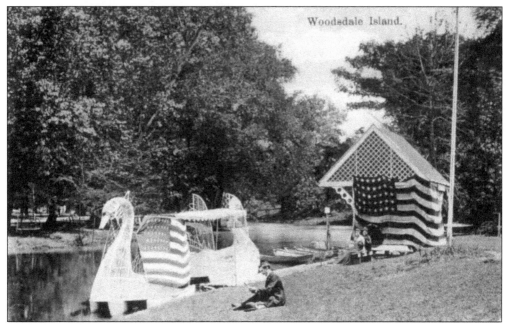

Woodsdale Island Park offered a variety of attractions that included the swan boat pictured here, a toboggan slide, a razzle dazzle, pony rides, swings, a dance hall, carousel, picnic grove, and bowling lanes. Overnight customers could rent a tent and sleep on the picnic grounds. Boat races and swimming matches were held on the Great Miami River. Other popular events included pig races, climbing greased poles, foot races, balloon ascensions, and fireworks. (Butler County Historical Society.)

Boat rides along the canal were available as well. Although the water was a popular attraction, it also played a key role in the park's demise. In 1898, the Great Miami River flooded and destroyed the dance hall. According to historian George Crout, the park had become a haven for illegal gambling, and alcohol abuse helped force the park to close in 1908. The closing of the canal and the Flood of 1913 destroyed what was left of the park. (Butler County Historical Society.)

The village of LeSourdsville served as a stopping point for canal boats in the late 1800s to pick up or drop off supplies or pick up blocks of ice cut from the fabricated lake to transport to Cincinnati. A village was developed by former French general Benjamin LeSourd that included a post office and a church, depicted in this 1980 painting by Anne Evans of Monroe, Ohio. (Author's collection.)

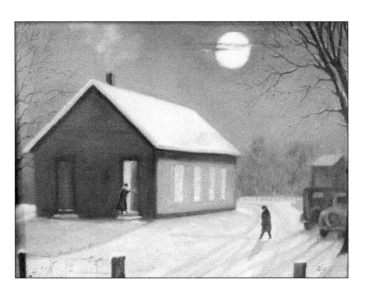

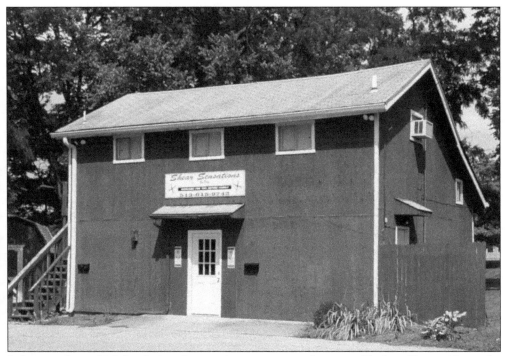

Icehouses along the lake during the canal years were used to store blocks of ice waiting to be transported. When the canal closed, the houses were repurposed, such as this one in Monroe housing Shear Sensations. Another is a residence right outside the main entrance of LeSourdsville Lake. In 1922, Edgar Streifthau tore down the remaining icehouses, dug out the old lake, and opened LeSourdsville. (Monroe Historical Society.)

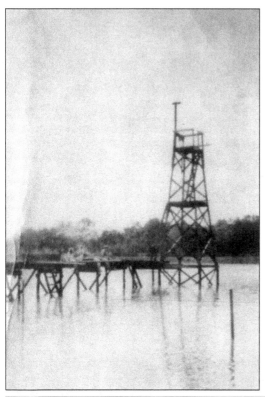

Streifthau used teams of horses to dig out the old ice pond and installed wells to pump water in from the Great Miami River. Part of the lake was used for swimming, while another part was exclusively for diving. This diving tower was built in 1923, a year after the park debuted. The diving towers were removed a few years later, as swimming became the primary attraction for most guests. (Monroe Historical Society.)

Children play marbles near LeSourdsville Lake during the late 1920s. Some residents called the park home year-round by renting cabins surrounding the lake. (Courtesy of Donald McKinley.)

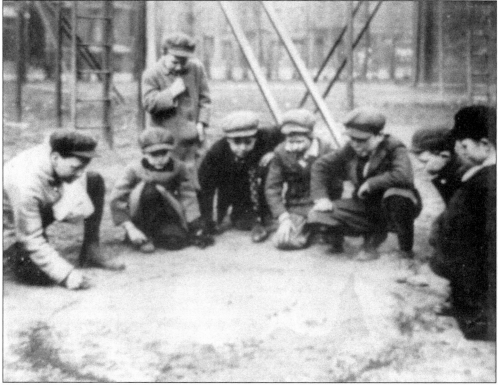

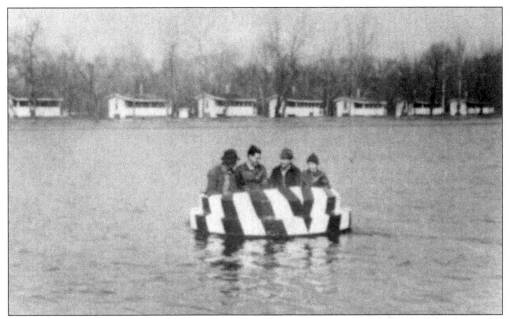

While it was Edgar Streifthau and his brother Ernest who opened LeSourdsville Lake, it was Middletown architect Don Dazey who moved the park toward becoming a full-fledged amusement park that would become popular with thousands in the tri-state area of Ohio, Kentucky, and Indiana. Dazey became a part owner in 1934 and began bringing in amusement rides, such as the Krazy Bugs, a rotating floating car developed by Streifthau that helped launch the park's popularity. (Monroe Historical Society.)

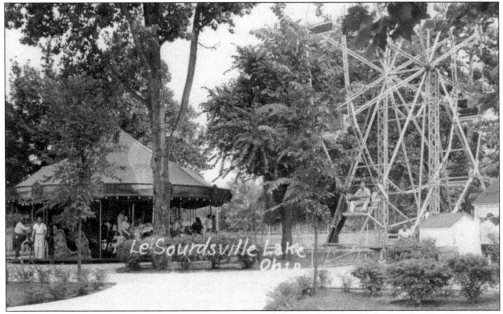

The first rides obtained by LeSourdsville Lake were this 1924 PTC-brand carousel and a Ferris wheel. Both rides remained popular as the park added more thrill-type rides. These rides were originally just inside the entrance. The carousel was later moved under a large wooden structure that protected it from the elements until it was destroyed by fire in 1988. (Monroe Historical Society.)

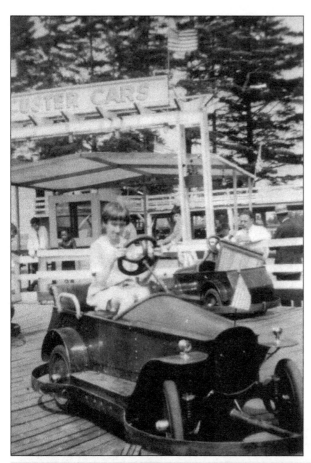

Dayton, Ohio–built Custer cars were all the rage with amusement parks across the country in the 1920s and 1930s, and LeSourdsville Lake ran them until the 1950s. The Custer car was a miniature steel-body ride that closely resembled an actual car. Riders were kept on course with just a steel rail along the edge of the track. (Monroe Historical Society.)

Besides mechanical rides, attractions became a mainstay for the park. In 1944, Stardust Gardens was built to accommodate the big bands that traveled throughout the country. Sock hops and disco parties became the norm in the 1960s through the 1980s. In 1990, an electrical short underneath the dance floor led to a fire that destroyed the building. (Monroe Historical Society.)

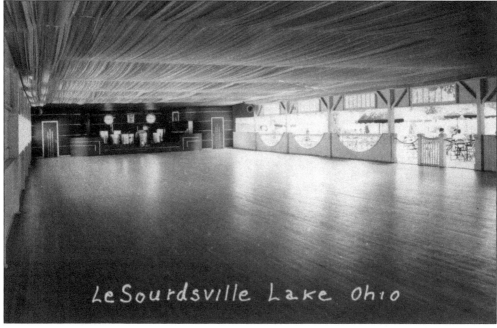

Although the lake was next to the Great Miami River, the elevation of the banks did not permit the park to utilize the river. Canoes were made available to use in the lake adjacent to the swimming and diving area. Lewis Shiverdecker and his wife, Lorna Nan Wright, took advantage of a romantic canoe ride to watch the divers and swimmers. (Courtesy of Todd Shiverdecker.)

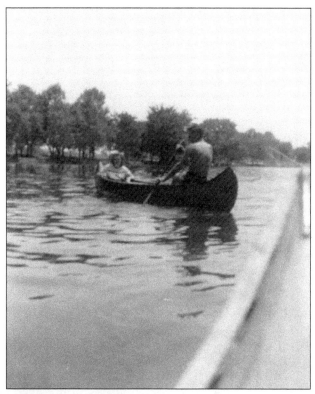

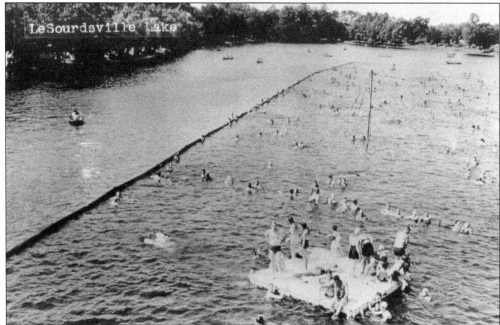

A concrete wall was installed to separate the swimmers from the canoe riders. A part of the wall still exists today. The canoes were eventually replaced by motorboats used in the same area. As the park expanded, portions of the lake were filled in and the boats were moved closer to the midway and ran between guide rails. (Monroe Historical Society.)

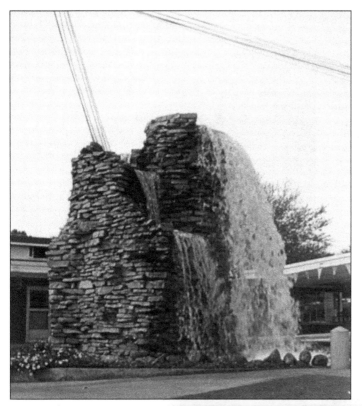

An iconic feature of LeSourdsville Lake was built in 1958; a stone fountain with a deer mounted on the top became a favorite place for picture taking. Adventurous teenagers found the attraction to their liking also. The prank of pouring soap in the fountain became a tradition for years until the fountain was torn down after the 1990 fire that destroyed the bathhouse nearby. (Monroe Historical Society.)

The Streco car was developed in 1955 by Edgar Streifthau and Frank Dodd in a small manufacturing building next to the entrance of LeSourdsville Lake. After testing at LeSourdsville, the car was marketed across the country, including nearby Coney Island in Cincinnati. Today, the car is a coveted collector's item and is often restored, such as this one Kevin Miller of Springfield, Ohio, is working on. (Courtesy of Kevin Miller.)

After Howard Berni and Frank Murru bought the park in 1960, the upgrades in attractions and rides continued thanks to the opening of Disneyland. Disney changed perceptions of what an amusement park should be. Gone were the dirt walkways and lack of landscaping. Music choices were no exception. The first rock group to perform at the park were the Crew Cuts, featuring (from left to right) Rudy Maugeri, Ray Perkins, Pat Barrett, and John Perkins. (Courtesy Nostalgia Central.)

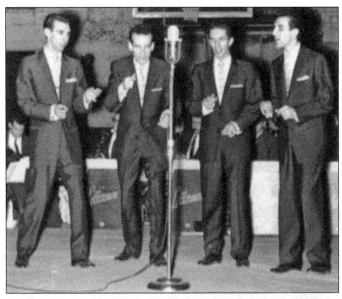

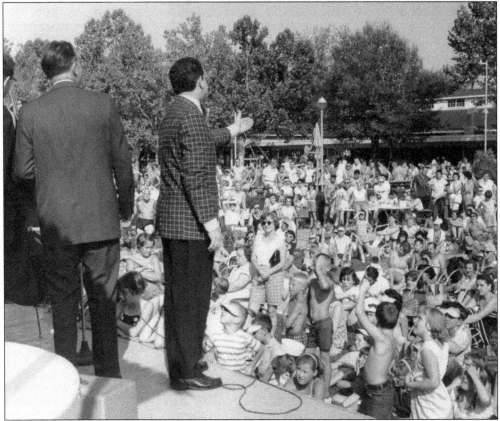

Another change included more partnerships with local media. This 1960 WKRC-TV Day was held during the 1960s with the Cincinnati station giving away a Pontiac to a lucky patron. Glenn Ryle (in plaid jacket), better known as "Skipper," was incredibly good at getting the crowd excited as the time grew closer to give away the car. (Monroe Historical Society.)

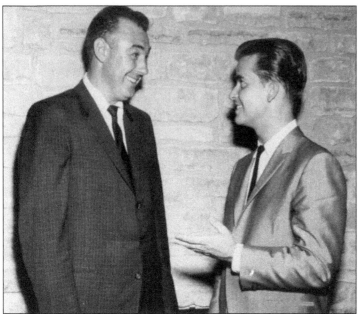

The host of *American Bandstand*, Dick Clark, traveled the country with the nation's top music talent, hosting shows and introducing acts. LeSourdsville Lake became one of Clark's stops in the early 1960s. Clark (right) is seen here discussing music with park owner Howard Berni in his Monroe home on Macready Avenue, where he would often host entertainers before and after their appearances on the midway. (Monroe Historical Society.)

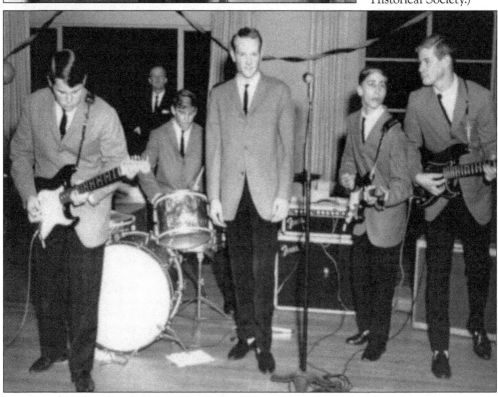

Just several weeks after their first hit, *Surfin' U.S.A.*, in 1963, the Beach Boys made their only appearance on the LeSourdsville Lake midway. At that time, the band consisted of (from left to right) Brian Wilson, Dennis Wilson, Mike Love, Al Jardine, and Carl Wilson. By 1965, the band had changed from its familiar "California Beach" sound to more experimental styles. (Beach Boys archives.)

In 1961, the park's third roller coaster was installed. It only lasted a couple of years, but it provided a viable alternative to the park's iconic coaster, the Screechin' Eagle (then known as the Space Rocket and previously as the Cyclone). The Wild Mouse roller coaster was a German model and was removed after the 1963 season. (Monroe Historical Society.)

Middletown, Ohio, classic car enthusiast Ken Neal was one of several local car owners who participated in the long-running Tri-State Custom Auto Show sponsored by the Middletown Pacemakers Club that ran from 1954 to 1965. He displayed his 1911 Detroit Electric on the midway during the 1962 show. The lake is visible to the right. (Roger Miller.)

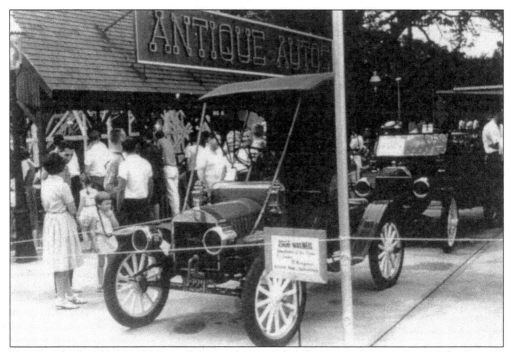

Ken Neal displayed his 1906 Maxwell during the same show. His car is sitting in front of the Antique Autos ride, which debuted just a couple of months prior to this show in 1962. LeSourdsville Lake played host to several car shows through the early 1990s, including custom vans and Chevrolet Corvettes. (Roger Miller.)

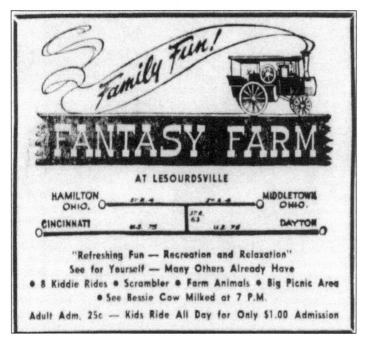

In 1963, Fantasy Farm Amusement Park was opened next door to LeSourdsville Lake by Edgar Streifthau, who sold LeSourdsville Lake in 1960. This newspaper ad barely mentioned "LeSourdsville" but was enough to generate a lawsuit by the owners of LeSourdsville Lake, claiming that Fantasy Farm was using a protected brand name. This ad sparked a series of lawsuits between the two parks until Streifthau sold Fantasy Farm in 1981. (Monroe Historical Society.)

The rides were very similar to what LeSourdsville Lake offered despite a noncompete clause in Streifthau's sales contract. Fantasy Farm was forced to give up its swimming pool until 1970, when the non-compete requirement expired. Streifthau installed rides such as this Santa Claus ride that was not a duplicate of anything at LeSourdsville Lake. LeSourdsville Lake added live animals, such as buffalo, chickens, goats, and a variety of birds to their attractions to address Fantasy Farm's claim to fame but ran into too many problems trying to manage them. One winter night, a number of buffalo escaped their pen to wander along State Route 4. All of the animals were returned to the park with the assistance of the Cincinnati Zoo except for one. Local celebrities such as Captain Wendy and Uncle Al (WCPO-TV), Bob Braun (WLWT-TV), Nick Clooney (WLWT-TV), the Cool Ghoul (WXIX-TV), Skipper Ryle (WKRC-TV), Duffy the Dog (WKEF-TV), and others began making annual appearances at both parks beginning in the early 1960s. (Monroe Historical Society.)

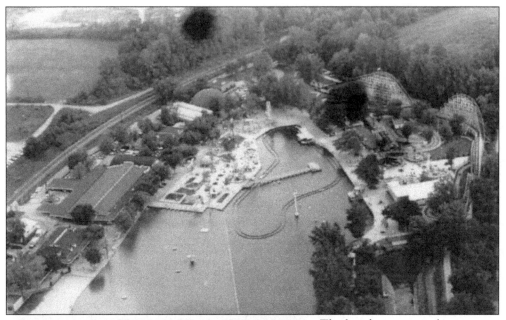

The beach was a popular destination for many guests looking to relax and enjoy the attractions. The remainder of the lake was used for special events like the 400-foot-long reproduction of Niagara Falls, water safety demonstrations by Doc Puthoff, and ski shows by the Ski Rangers, Wiedemann's Ski Ballers, the Tri-County Water Ski Club, and the Show of Champions, which featured 10 of the nation's best water skiers. (Monroe Historical Society.)

Believe it or not, the iconic water tower became a source of legal issues between LeSourdsville and Fantasy Farm. When Streifthau sold LeSourdsville in 1960, he maintained a private water company that serviced water to LeSourdsville. It is believed that Streifthau intentionally diverted polluted water into the LeSourdsville property and stopped filling up the water tower, creating water shortages for the amusement park. (Monroe Historical Society.)

The newly planted trees pictured here that separated LeSourdsville and Fantasy Farm died mysteriously in 1971. Officials at LeSourdsville made a police report with the Butler County Sheriff's Office, and it was determined that the trees were poisoned. No one was ever arrested connected to the case, but legal issues between the two parks continued. (Monroe Historical Society.)

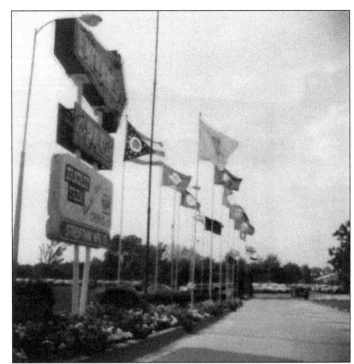

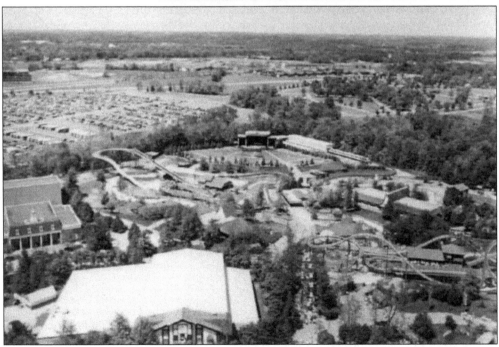

Kings Island, opened in 1972, quickly drew over a million people a year. LeSourdsville owner Howard Berni commented on the opening at the time, "We were a thorn in the side of Coney Island because we pulled patrons away. We are sure they're going to know we're still here when Kings Island opens. We aren't going to fade away. They have the worries, not us." (Kings Island archives.)

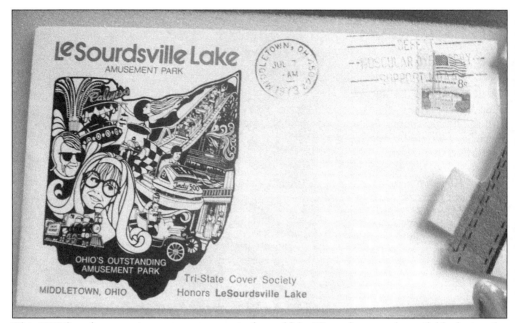

This 1973 first-day cover is a very rare souvenir that sold for 35¢ and was made available during the second (and last) LeSourdsville Stamp & Coin Show, sponsored by the Tri-State Cover Society. Tri-State was a very popular nonprofit organization that hosted multiple stamp and coin shows throughout Ohio, Indiana, and Kentucky. It produced colorful and unique collector covers for a variety of events, such as at LeSourdsville. (Monroe Historical Society.)

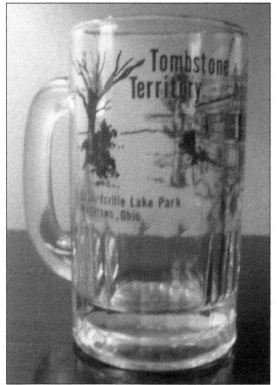

Any LeSourdsville fan most likely has at least one of these mugs. This second-generation glass mug featured the park's only themed area, Tombstone Territory. The first generation of mugs was produced in the mid-1960s when Tombstone Territory was developed and quickly became popular with kids and adults. They were only sold in the saloon in Tombstone, where a matching gallon pitcher was also available. (Monroe Historical Society.)

This 1974 advertisement featured the fifth annual Boat, Camper, and Mobile Homes Show at LeSourdsville. While having shows similar to this was common to bring crowds into the park, it is ironic that one of the exhibitors—Couch's Camper Sales of New Miami, Ohio—would end up purchasing LeSourdsville in 2000 and saving the park from closing permanently. (Monroe Historical Society.)

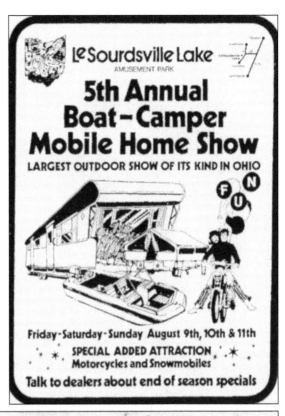

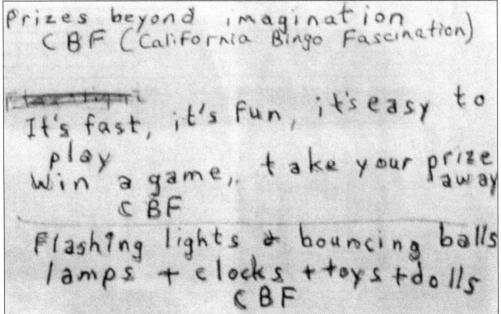

One of the favorite places was the Fascination Bingo building. Playing Fascination was a lot of fun, and some people won great prizes. The building was also one of the few in the park that was air-conditioned. On the speaker system on the outside of the building, one could usually hear the pitch inscribed on this cheat sheet to draw people inside to play. (Lois Woike Villarreal.)

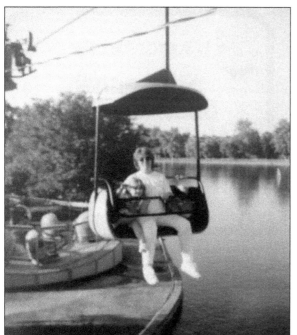

While part of the lake was filled in near the main midway, portions of it were reserved to allow the new 1965 Skyride to be built over it. The water was only a couple of feet deep in this area, but many people had thoughts about jumping into the murky water. Teresa Alexander (left) and her mother, Ruth Otto, enjoy a casual cruise over the lake, eyeing their next ride challenge. (Courtesy Teresa Alexander.)

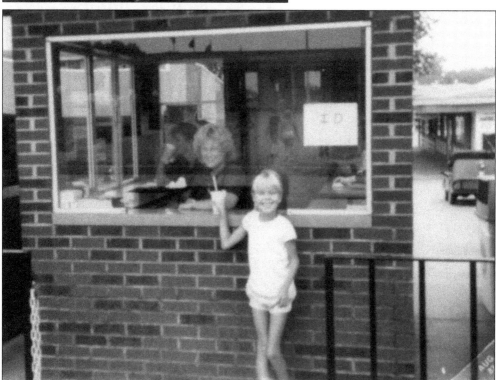

Employees working the ticket booths served as the foundation to everyone's fun day at the park. They were the first to greet the guests and set the stage for the rest of the day with their friendly attitude and quick service. Here, little Amy Ewen of Trenton, Ohio, is all smiles after receiving her admission ticket from Jill Fisher and ready to head to her first ride of the day. (Jim McEwen.)

This rare souvenir was issued in 1976 during the park's US bicentennial celebration. LeSourdsville was recognized as the nation's first "Bicentennial Amusement Park." Promotions director Bill Robinson obtained the designation after highlighting the park's various promotions, including the installation of a Liberty Bell that had a device allowing patrons to hear a taped message highlighting the bell's history and automatically activating a bell sound at the end. (Monroe Historical Society.)

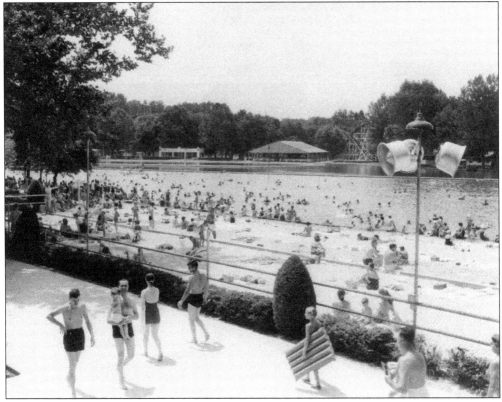

Swimming in LeSourdsville Lake was a tradition that dated to the park's opening in 1922. Through the years, the lake was divided to allow for other activities such as boating, skiing, high-platform diving, and two showboats. At the conclusion of the 1975 season, lake swimming was permanently discontinued, and the beach area was filled in to allow for additional picnic shelters. (Monroe Historical Society.)

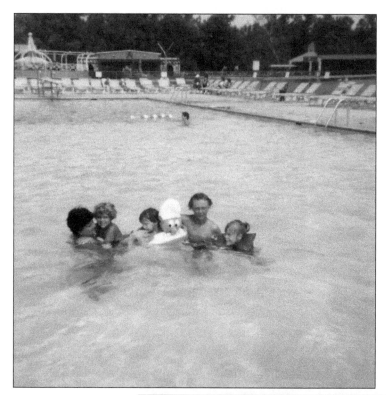

From left to right, Lani Steiner, Jason Phillips, Christian Roark, Amy Ewen, and Jaci Slusher enjoy the new Blue Dolphin, an Olympic-size swimming pool that opened in 1976. The pool was 50 by 100 feet long and had a capacity of 190,000 gallons. Swimmers missed the sandy beach, but the new pool allowed for safer swimming conditions and served as the launching pad for the park's multimillion-dollar update that expanded the midway. (Jim McEwen.)

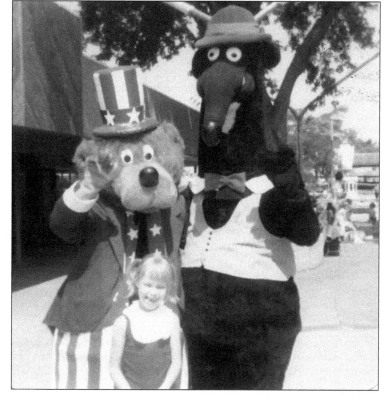

Amy McEwen stands in front of two of the park's newest mascots: Uncle Freddy and Wally the Weasel. Amy's brother Jim was one of the employees honored to wear the Uncle Freddy costume despite the many hot and humid days when the park was open. (Courtesy Jim McEwen.)

# Two
# A SURVIVOR OF MAJOR CHANGES

Competition for any amusement park includes any event going on or any another amusement park. After the federal interstate highway system was started in the late 1950s, traveling long distances to other amusement parks became easier. LeSourdsville Lake's competition from the 1940s through the 1960s was Coney Island in Cincinnati, Lakeside Park in Dayton, and Forest Park just north of Dayton. In 1963, Fantasy Farm Amusement Park opened next door to LeSourdsville Lake and the competition and lawsuits began.

When Coney Island closed and moved most of its rides to Kings Island in 1972, many predicted that LeSourdsville Lake would soon close. The additional crowds at Kings Island actually helped, since the park already had a very positive reputation outside of the Cincinnati and Dayton area. LeSourdsville Lake started a multi-million-dollar expansion in the mid-1970s that probably would have occurred regardless of Kings Island. The park incorporated a name change to Americana to appeal to a wider audience outside the Ohio, Indiana, and Kentucky area. Previously, advertising for the park was kept within the Cincinnati and Dayton areas. LeSourdsville Lake also had a superior reputation in catering picnics for small and large groups.

The recession in the early 1980s and rising gasoline prices began to take their toll on Americana as businesses cut back on employee benefits such as company outings. In 1984, the park debuted its most expensive ride ever installed, the Raging Thunder log flume. Four years later, a fire destroyed the park's 1924 PTC carousel and Dodgem ride. Americana came back the following year and opened the Serpent, the park's fifth roller coaster in its history. In January 1990, a major fire destroyed the bathhouse, concession stands, the Stardust Gardens ballroom, and parts of several rides kept inside the bathhouse during the winter. The result of the fire and a foreign-student work program that backfired forced the park into bankruptcy.

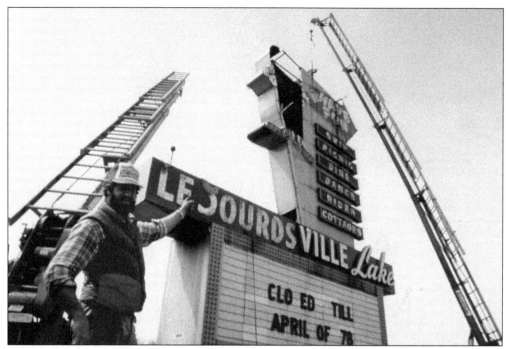

In 1958, this iconic sign complemented the expansion of State Route 4 in front of the park and made it easier for first-time guests to find LeSourdsville Lake. As part of the park's major expansion, the park changed its name to Americana, "the Great American Amusement Park," and necessitated an update to the sign. Ron Berni, vice president of Americana, is shown here supervising the efforts to remove the old sign. (Monroe Historical Society.)

The new entrance sign exhibited the park's new colors, orange and blue, along with the new name. The sign underwent color changes through the years but stayed an icon until 2019, when it was completely torn down and the area was converted into a roadway. (Monroe Historical Society.)

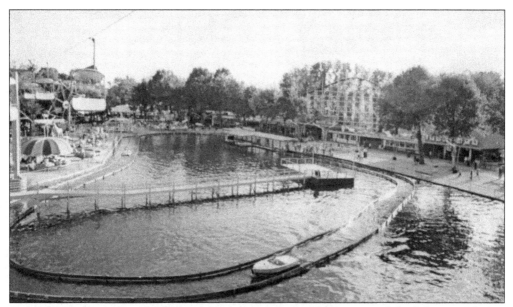

One of the other major changes for Americana was the elimination of the lake stage. It was moved to the former children's area, which moved next to the Blue Dolphin swimming pool. This brought the stage closer to guests and allowed for larger crowds. A food concession building was constructed on the right side of this photograph along with a new showboat dock. (Monroe Historical Society.)

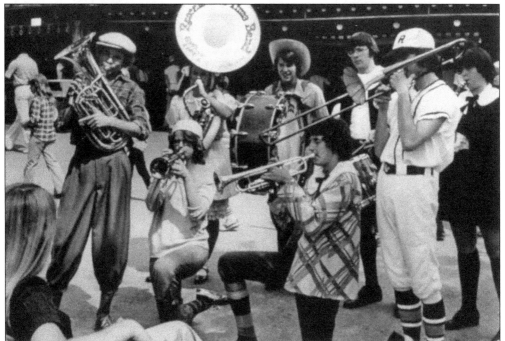

The Little Rascals Funtime Band was another way to entertain guests and provide some performing experience to the area's talented high school and college musicians. The person orchestrating the different musical groups was Tom Buchanan, who worked as the music director for Lemon-Monroe High School near Americana. (WHR Inc.)

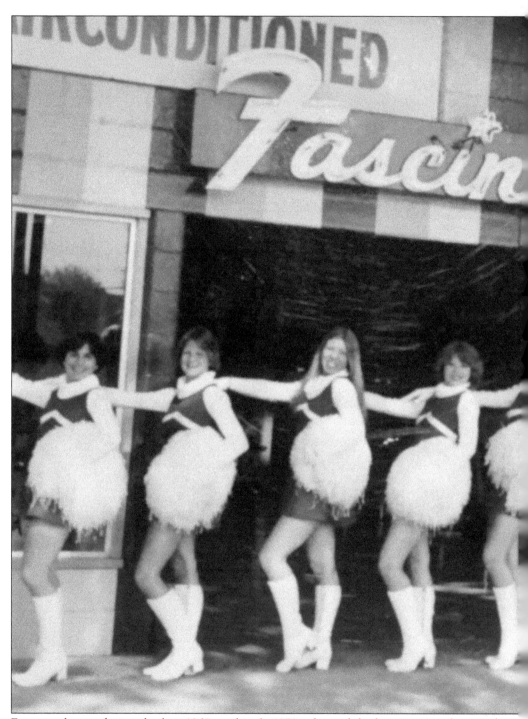

For several years during the late 1960s and early 1970s, the park had an opening day parade led by a local high school band. The park also hosted a dedicated Butler County city day and provided discount admissions for residents that usually included a marching band from the high school representing the city. A number of high school bands performed, including from Monroe, Middletown, Ross, and others. In 1978, the Fairfield, Ohio, high school used Americana as a

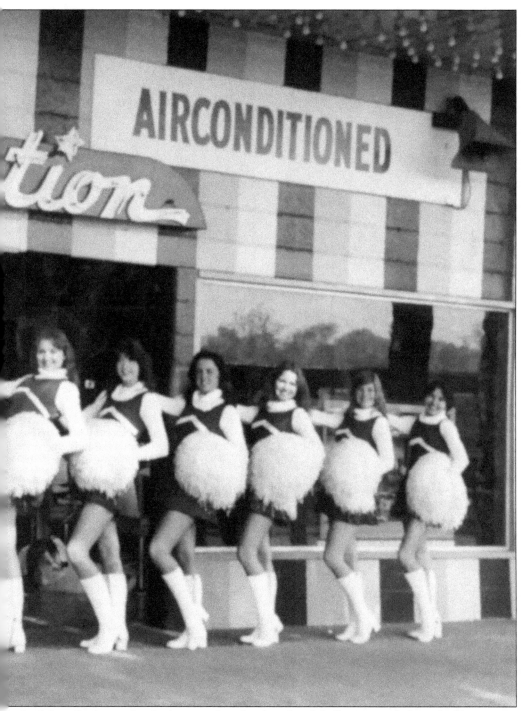

backdrop for its yearbook photographs of its band and drill team, including the Fascination building. Pictured here from left to right are Brenda Wear, Tracy Hutzelman, Nancy Lewis, Celica Elick, Jana Bradbury, Bobbie Badge, Kim Vennefron, Kim Wilcox, Cheryl Baker, Darlene Burns, and Bonnie Schlabach. (WHR Inc.)

The Funtimers Dixieland Band was one of several bands composed of high school students that made their debut in the mid-1970s. Other groups included the Little Rascals Funtime Band and a Fife & Drum Corps that roamed the park on weekends when it was crowded. For many years, the Country Music Show in the saloon in Tombstone Territory was broadcast on WPFB-AM in Middletown, Ohio. (Monroe Historical Society.)

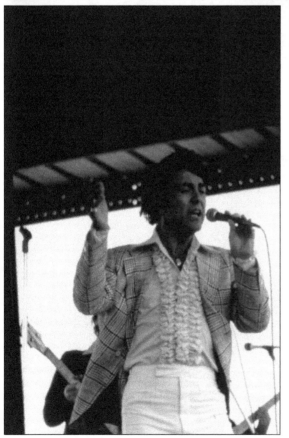

Many of the entertainers who appeared in the 1960s were part of Dick Clark's Caravan of Stars series. In 1976, Dick Clark's Rock N' Remember Show debuted, with Clark making his third and last appearance at Americana the following year. Freddie Cannon was one of the more popular singers to entertain on the midway, including his No. 3 Hot 100 hit "Palisades Park." (WHR Inc.)

Chuck Berry entertained thousands of fans on the Americana midway in this 1977 Rock N' Remember Show. Over the years, the number of stars who graced the stage included Bo Donaldson & the Heywoods, Herman's Hermits, the Drifters, Chubby Checker, Tommy James, Gale Watson & Kentucky Morning, Billy Jo Royal, Roy Orbison, Willie Nelson, and many others. (WHR Inc.)

Doris Coley was another popular singer who graced the Americana midway as part of the Rock N' Remember show, but most guests only recognized her as the lead singer of the Shirelles during their revival in the mid-1970s. The Rock N' Remember shows were sponsored by WSAI-AM in Cincinnati. (WHR Inc.)

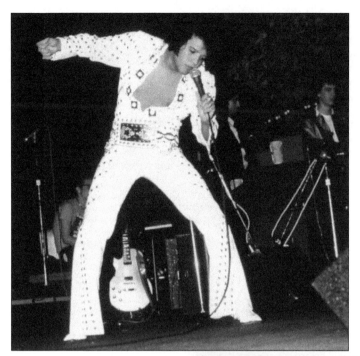

Songwriter and Elvis tribute artist Rick Saucedo ended up entertaining at Americana just two weeks after Elvis Presley died. Although Americana never released attendance figures, the crowd was estimated to be over 10,000. Saucedo made numerous appearances at Americana over the years and was one of the few national acts performing at the park in the 1990s. (WHR Inc.)

You are not seeing double in this picture. This Elvis tribute artist was actually an Americana employee displaying his talent. Glenn Bowles was attending Middletown High School when he made his debut at Americana. Bowles not only continued his Presley tribute shows but was also a member of the Van-Dells from 1990 to 2015, who also entertained at Americana. (WHR Inc.)

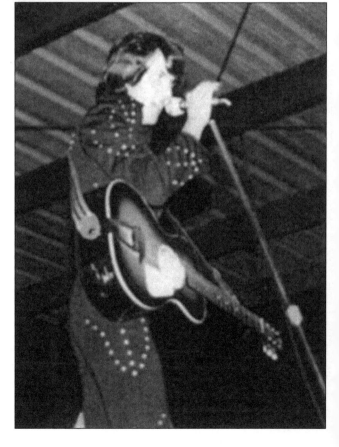

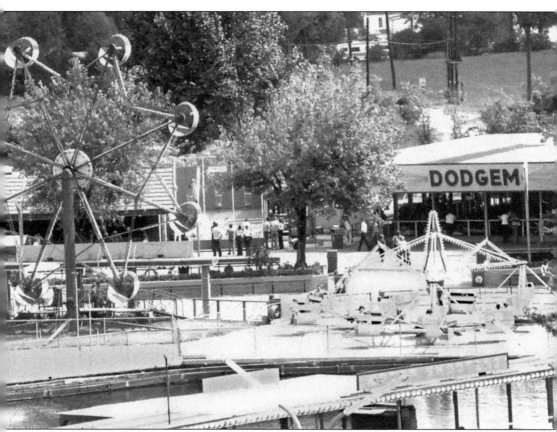

The Rock-O-Plane ride dates to 1951 and was moved around often to give the appearance of new attractions. This ride operated similarly to a Ferris wheel except each car could be individually turned upside-down by the rider. When the park closed after the 2002 season, the ride was sold to Coney Island, where it ran until it was sold off after the 2019 season. The Scrambler ride on the right was later moved back to Logger's Run in the late 1980s. (WHR Inc.)

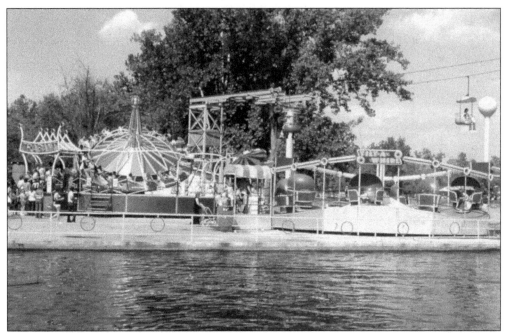

The Trabant (left) was added to the park's ride lineup as a result of the expansion. The Tilt-A-Whirl was added in 1951 but has been located throughout the park over the years, including as part of the midway expansion. The Trabant was taken out by 1980. The Tilt-A-Whirl was used through the 2002 season; however, it is not known who bought the ride when the park finally closed. (WHR Inc.)

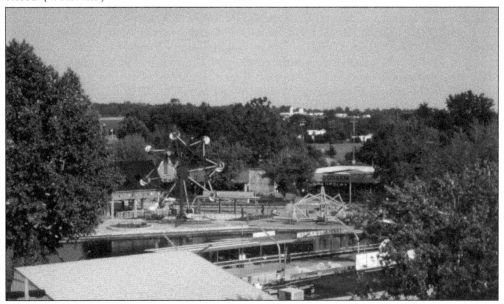

The motorboat dock is seen here shortly before it was renovated and renamed Skipper's Wharf, complete with a covered area over the dock and waiting queue. Behind the Rock-O-Plane ride is the Skyride building, added in 1965. The Skyride building was one of the few structures saved from destruction after the park closed permanently and is destined to become home to a launch site for a zipline attraction. (WHR Inc.)

The Screechin' Eagle roller coaster stood out as the most popular ride in the park since it was introduced in 1940. It was built in 1927 for Moxahalia Amusement Park in Zanesville, Ohio, and moved to LeSourdsville in 1939. Its original name was the Cyclone and changed to the Space Rocket in 1960. After the park completed its expansion program in 1978, the name was changed to the Screechin' Eagle. (Alfred Freeman.)

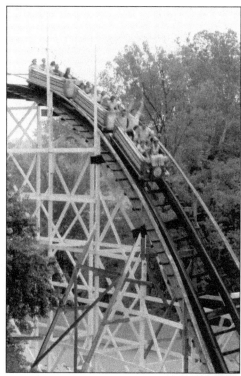

American Coaster Enthusiasts members always enjoyed riding the Screechin' Eagle. After the park closed, an attempt to move the coaster to another park was planned but was not economically feasible. In August 2001, the coaster was torn down, and a portion of one of the cars was preserved by a private citizen. Another piece is on display at the Monroe Historical Society. (Alfred Freeman.)

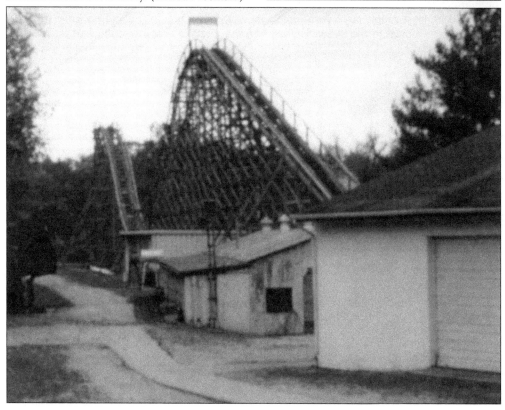

Circus entrepreneur Tommy Hanneford opened Circus International, featuring Princess Tajana and her Siberian and Bengal tigers, flying trapeze artists, basketball-playing boxer dogs, and the Hanneford military elephants in a 1,200-seat circus tent. Hanneford operated the circus at Americana for a couple more years. The tent stayed a fixture on the midway until the park closed and was moved to the former Fantasy Farm property, where it continues to sit dormant today. (WHR Inc.)

Jim McEwen was certain there was a scary ending to the haunted house attraction. LeSourdsville Lake's haunted house was created by Bill Tracy, an internationally known haunted house designer. Tracy's creations were built exclusively for each park; however, it is not known what features LeSourdsville Lake requested when it installed the attraction in 1968. The attraction was removed after the 1982 season. (Walter Ewen.)

This boat dock in Tombstone Territory (later named Logger's Run) served as an alternative to riding the train or walking back to the park's only themed area. LeSourdsville first offered a boat ride in 1956 that ran in circles in the lake, since Tombstone Territory had not been developed yet. In 1975, a larger boat constructed in nearby Lebanon, Ohio, was christened by Ohio state senator Donald Lukins. (WHR Inc.)

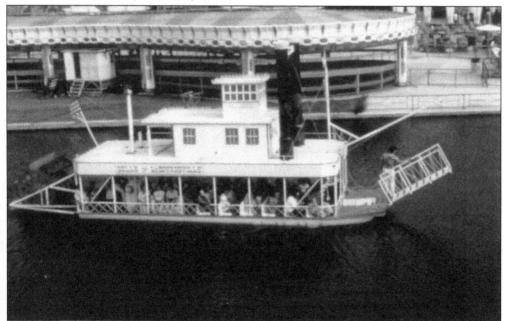

The *Belle of LeSourdsville* was the park's largest boat, accommodating 65 passengers. It was originally designed to look like the *Chaperon*, a paddle-wheeler that ran in northern Ohio in the late 1800s. The boat ran until the end of the 1999 season and was kept by the park but not used during the last season in 2002. The frame was eventually sold for scrap in 2016. (WHR Inc.)

Jaci Slusher (left) and Jennifer Siebert practice their coaster moves on the Little Dipper, a kids roller coaster that packed a surprising punch for unsuspecting riders. The park bought the ride in 1968 to replace the Jack Rabbit. After the park closed, the ride was sold to Sluggers & Putters in Canal Fulton, Ohio, where it continues to give younger riders a thrill. (Jim McEwen.)

The gasoline-operated Water Skooters made their debut in 1949 and became very popular. The boats rode within wooden guide rails and had speed controls installed. Christian Roark shows that even the smallest guest could manage driving a boat around the track. Taller riders had to drive with their knees up against the steering wheel. The motorboats were replaced by pedal boats in the late 1980s. (Jim McEwen.)

One of the rides that was moved around the park the most was the Rock-O-Plane. The ride made its debut in 1951 and operated until the cars were destroyed in the 1990 fire. The cars were replaced, and the ride continued until the park closed in 2002. The ride was sold to Coney Island in Cincinnati, where it ran until Coney closed its rides section in 2019. (WHR Inc.)

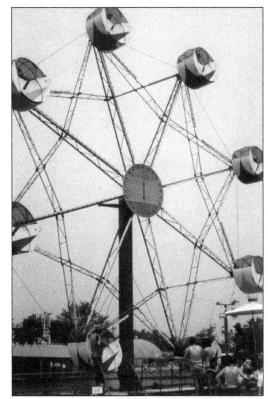

Rock-O-Plane riders roll upward as the ride spins high in the air. The ride runs similar to a Ferris wheel; however, the seats are enclosed and rock and roll as the ride turns upward. Adventurous riders can rock the car back and forth, forcing the car to eventually flip upside down—sometimes multiple times. (Jim McEwen.)

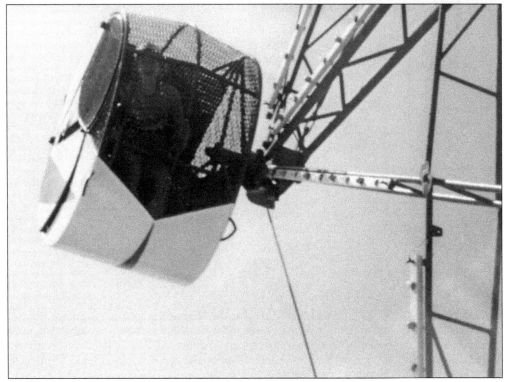

Jimmy McEwen (left) and his younger sister Amy ride the Paratrooper, one of the few LeSourdsville Lake rides that was formerly a portable carnival version. The ride was obtained in 1964 and advertised as a thrill ride since the seats were designed to move freely as the ride went around. After the chairs were destroyed in the 1990 fire, the ride was retired. (WHR Inc.)

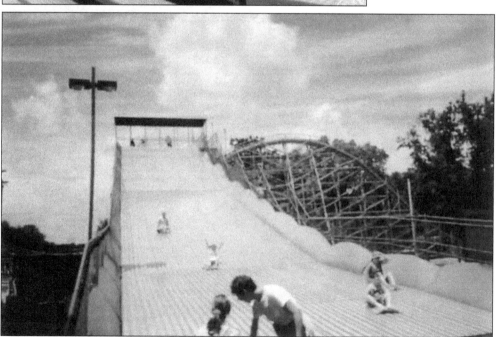

The Super Slide was one of the largest of its kind and was similar to the one at Kings Island. It allowed riders to "race" each other down to a carpeted landing area. It also provided a great view of the park and a unique view of the Great Miami River on the opposite side. After LeSourdsville Lake closed in 2002, the ride was sold for scrap due to its deteriorating condition. (WHR Inc.)

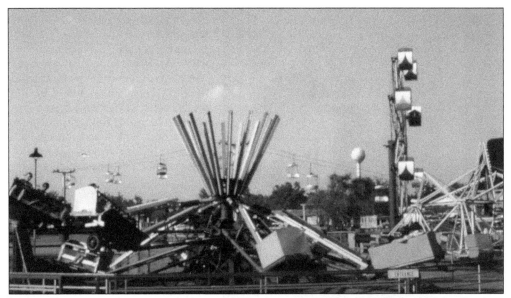

Is it a roller coaster or is it just another ride going in circles? This ride's developer, John Bartlett, marketed it as the Flying Coaster because of the single, sharp slope in its circular track that forced cars into the air. LeSourdsville Lake went with the Flying Coaster name from its start in 1963 until the ride was retired in the late 1980s. (WHR Inc.)

Marla Singer (left) and her daughter Jaci Slusher get ready to take a ride on the classic Scrambler. Hopefully, Jaci chose the correct side of the car, or she would take the chance of getting jammed. The timeless Scrambler was obtained in 1961 and was still running when the park closed in 2002. In the background is part of the large building that housed Fascination and a variety of games. (Jim McEwen.)

Food courts were common at amusement parks for decades before becoming popular at shopping malls. Americana offered an array of tempting foods as soon as one entered the park. The main restaurant was on the right, and concession stands offered everything from cotton candy to corn dogs. This is actually a park employee picking up a load of hot dogs for another stand. (WHR Inc.)

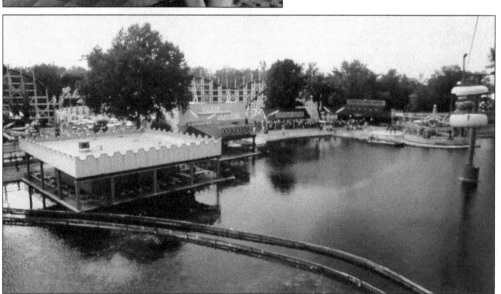

To maximize space, part of the lake was filled in in the mid-1970s to accommodate the grey building on the left. The structure was built exclusively as a food outlet with convenient seating surrounding the lake. This concession offered specialty ice cream when it first opened. It closed as the Americana Diner offering hamburgers, hot dogs, French fries, and pretzels. (WHR Inc.)

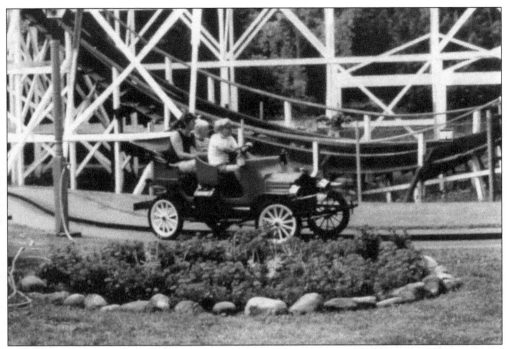

The Antique Autos offered some great views of the Screechin' Eagle roller coaster since most of its path was adjacent to the classic coaster. It also offered relief for tired parents to take part on a ride with their children and "let them do the driving." This ride was designed by park owner Howard Berni in 1962 and retired after the 1989 season. (WHR Inc.)

Longtime Americana employee Ginny Rathburn was just one of many dedicated employees who put in long hours and loved working at the park. Rathburn displays her enthusiasm here with Amy Ewen as she sorts out park brochures for distribution. Employees like Rathburn served as unofficial ambassadors of the park by showing their willingness to help guests and were enabled to do whatever it took to make guests happy. (Jim McEwen.)

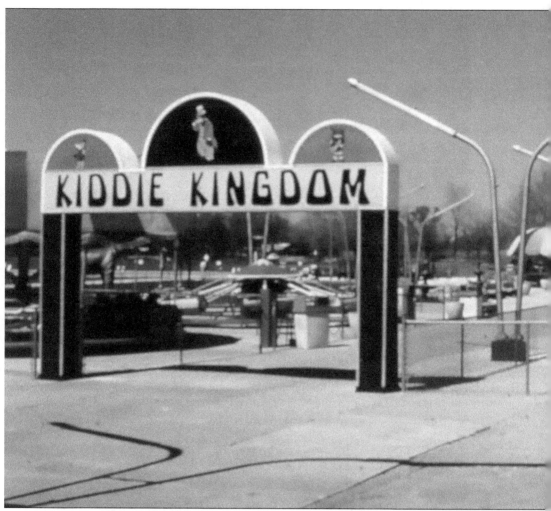

Americana had one of the largest areas dedicated to small children of any amusement park in the country during the 1980s. The area was called Pinocchio Land in the 1960s, and Kid's World in the 1990s. Despite the name changes, the area offered an iconic lineup of children's rides that rivaled its neighbor, Fantasy Farm. Rides over the years included the 99 train, a number of Hampton-

brand rides, a carousel, an elephant ride, a boat ride, hand cars, the Jack Rabbit and Little Dipper roller coasters, the Old Lady in the Shoe slide, swinging chairs, and others. Longtime employee Marlene Homsher served as an entertainment manager, including Kiddie Kingdom for almost 20 years and served as another example of the dedicated employees who served guests. (WHR Inc.)

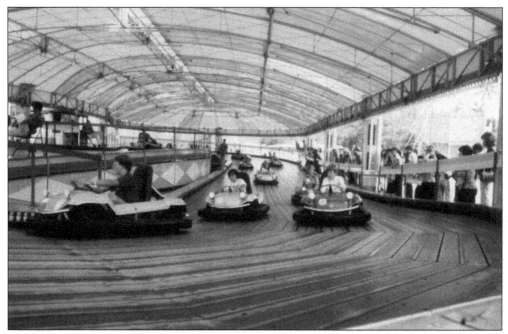

The Indy 500 auto ride made its debut in 1973 and created opportunities for kids of all ages to drive an electric-powered race car around the oval track with some elevation at the curves. The ride was removed sometime in the late 1980s, and the area was transformed into a picnic shelter. (Monroe Historical Society.)

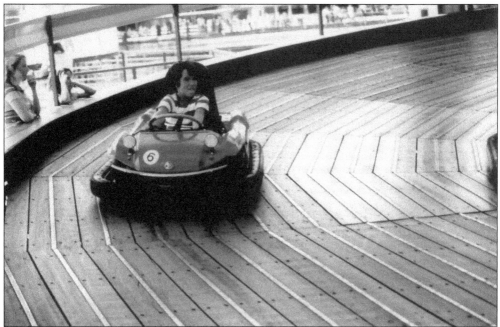

One of the more interesting aspects of the Indy 500 ride was that each car had a protective rubber guard around it since it was a guarantee that riders would run into each other. There were no guide rails to keep cars in their lanes, so it was a combination of a demolition derby–style ride and the Speedway cars. (WHR Inc.)

Pierre LeSourd stood out among the Crazy Fun Critters due to his height. The character was named in honor of the village of LeSourdsville, the area where Americana was located until the mid-1990s, when the City of Monroe annexed the park. The costume did not have a fan, so air circulation was limited, and employees wearing it often lost weight after spending an afternoon in the sun. (WHR Inc.)

Between rides, there was always food. If guests were part of a company or church outing, Americana's catering teams would serve until the last baked bean was eaten. The catering teams were often made up of friends and relatives of park managers who would come together when the park hosted a large outing, such as ARMCO Steel or Champion Papers, and serve homemade fried chicken, baked beans, rolls, and mashed potatoes. (WHR Inc.)

Guests probably never gave much thought to the park's extensive landscaping efforts. A well-managed park should have curb appeal, and Americana strived to always keep up the landscaping and plant flowers to help soften the concrete walkways and retaining walls. Americana employed a dedicated grounds crew who spent their time after the park closed for the day cleaning, power washing, and emptying trash cans. (WHR Inc.)

Richard Butterfield and Jim Ewen wait on guests to be seated before leaving the Tombstone Territory station and head back to the main midway on the Iron Horse train ride. Shortly after the ride was installed in 1965, riders experienced cowboy and Indian battles and attempted train robberies until the sheriff arrived to take care of the bad guys. (WHR Inc.)

John Robinson sits on a rare wooden horse on the 1924 PTC carousel in this 1980 photograph. John's father was park vice president William "Bill" Robinson. After Bill left Americana after the 1982 season, he opened a marketing firm specializing in medium to small amusement parks across the country. John joined his father at WHR Inc. and continues to manage the company today. (WHR Inc.)

Americana enabled people of all ages to enjoy a menu of healthy and not-so-healthy meals, ride the rides, or just relax along the midway, like Grover Ashley, Brenda Ewen, and her daughter Amy. The ride behind them was the Sombreros, which enabled riders to spin their cars as the platform spun around. (Walter Ewen.)

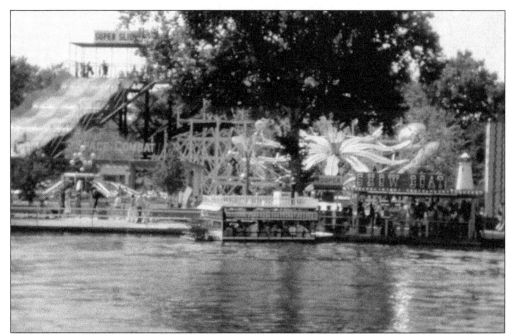

The midway was very crowded with rides and concessions, and management was forced to fill in parts of the lake for expansion. The showboat dock was expanded to accommodate a larger showboat, and the Space Combat ride was eventually moved to another location. The flower-looking ride is the Paratrooper, which was moved toward the front of the park. (WHR Inc.)

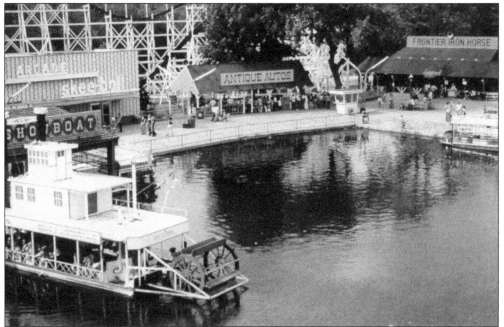

The Iron Horse train building on the right was torn down after the 1977 season, and the midway was expanded to allow for the Hanneford Circus tent, a concession building, a miniature golf course, restrooms, and a new train station. This would be the last major expansion the park undertook before moving its attention to remodeling Tombstone Territory. (WHR Inc.)

Crazy Fun Critter Rocky Raccoon and park mascot Uncle Freddy entertain guests in front of the bathhouse that was constructed in 1934 after a fire destroyed the first building. The bathhouse served an important function during the summer by supplying a spacious area to change for the swimming pool, but it also provided storage for rides during the winter to protect them from the elements. (WHR Inc.)

Space Combat was a carnival ride converted to the Americana midway in 1968. The popular carnival version was a quick hit for the park and made it a must-ride, since it was not running at any other park in Ohio, Indiana, or Kentucky. The ride was removed in the late 1980s due to maintenance issues. (Walter Ewen.)

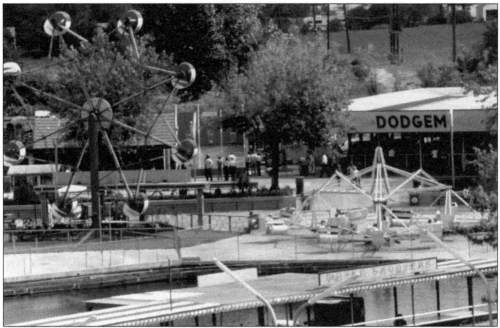

One of the major advantages of visiting Americana was that rides and attractions were relatively close to each other, creating a short path from ride to ride. It was also rare to stand in line for any ride, including the popular rides like the Rock-O-Plane, Dodgems, or the Scrambler, for longer than a few minutes, unlike at larger parks. (WHR Inc.)

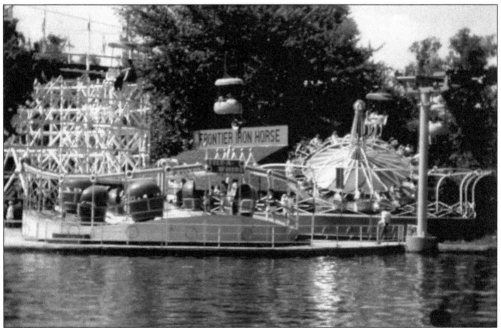

Americana was always considered a family-oriented park, and it was common for older children to go from ride to ride by themselves while their parents relaxed in the picnic grove or along the midway. Americana provided a safe atmosphere, and parents always had the perception that the park was well managed. (WHR Inc.)

The Crazy Fun Critters not only entertained guests along the midway but also sang (lip-synced) to Top 40 hits on the Midway Stage. Uncle Freddy served as the lead singer in this 1980 photograph as Rae handles the background vocals. Rae's partners included Do, Mi, and Fah and joined Pierre LeSourd, Rocky Racoon, Wiley the Weasel, Drake the Duck, and Cheddar the Mouse as costumed characters. (WHR Inc.)

The Flying Wallendas, the internationally known circus group of daredevil stunt performers who perform high-wire acts without safety nets, spent two tours at Americana, with the first one in 1981 inside the former circus tent. Their second appearance was in 1997 outside over the lake. The most famous member of the family is Nik Wallenda, who began professionally in 1992 and holds 11 Guinness world records. (WHR Inc.)

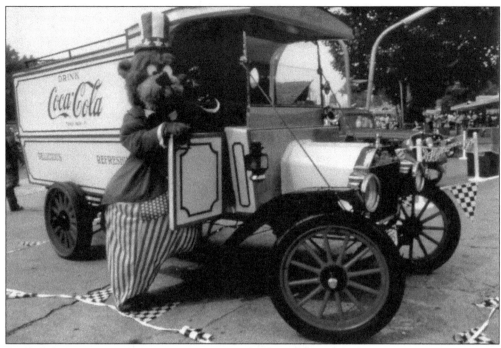

Coca-Cola was a major sponsor at Americana for many years and often participated in some of the park's special events such as the Rock N' Remember music series and a variety of car shows, including this one from the early 1980s. Of course, Uncle Freddy had to make an appearance to make it an official Americana event. (WHR Inc.)

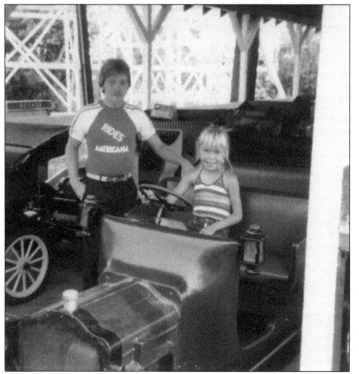

Ride operators such as Norman were well trained in loading and unloading guests and emergency procedures. Ride operators acted as first responders in the event of an emergency. These employees were another important part of guests having a great time and choosing to make a return visit. A smiling Amy Ewen seems content getting to drive one of the antique cars and is another happy guest. (Walter Ewen.)

Joe Faggionato spent his childhood at Americana since his family owned the majority of the game concessions from the 1960s through the 1990s. He is one of several children of park owners or managers who spent their lives learning about the amusement industry. Faggionato ended up becoming part owner of Americana in 1991 when he and three others bought the park out of bankruptcy. (Jim Ewen.)

Games attendant Robbie smiles as he prepares to convince the next guest to knock down the bottles for a great prize. Games employees had to be personable and outgoing in order to attract guests to their concession. While the chances were almost always in the game's favor, most guests still enjoyed trying to impress their date or friend by winning that big prize. (Jim Ewen.)

Tombstone Territory was Americana's only themed area and originally consisted of false-front buildings similar to a movie set. Actors were employed to play cowboys and fall off buildings or into props as they were "shot" by the sheriff and his posse. The saloon was the first real building, constructed in the early 1970s, followed by a building to house an arcade, a photography shop, and an ice-cream parlor. (WHR Inc.)

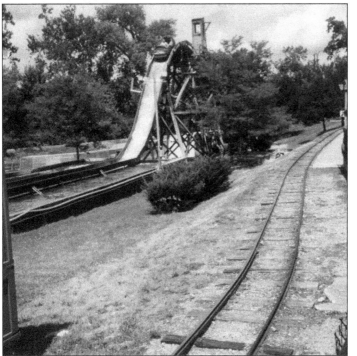

Tombstone Territory's name was changed to Logger's Run in 1984 after the addition of the Raging Thunder log flume, Americana's most expensive ride ever installed at about $1 million. A waterfall was installed at the end of a wood tunnel that guaranteed the rider would get wet. Log flumes at other parks could not make the same guarantee, making this ride a favorite among national enthusiast groups. (Monroe Historical Society.)

In 1985, the park held an auction and sold the carved wooden horses and decorative side panels from its 1924 PTC carousel. Today, these works of art sell for anywhere from $5,000 to $15,000 depending on condition. The wooden horses were replaced with aluminum versions that looked similar but lacked the character the original horses provided. (Monroe Historical Society.)

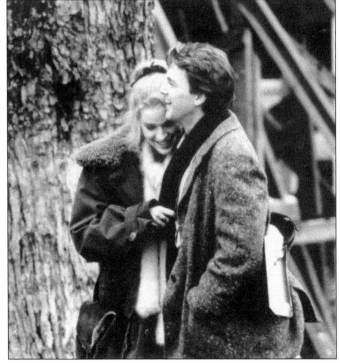

In 1988, a $14 million motion picture that was produced primarily in southwest Ohio made its debut across the country. *Fresh Horses* featured Molly Ringwald and Andrew McCarthy, fresh from their previous movie together, *Pretty in Pink*. The only scene filmed at the park to make the final cut featured Ringwald and McCarthy walking along and on parts of the Screechin' Eagle roller coaster, discussing their odd relationship. (Courtesy Sony Pictures Inc.)

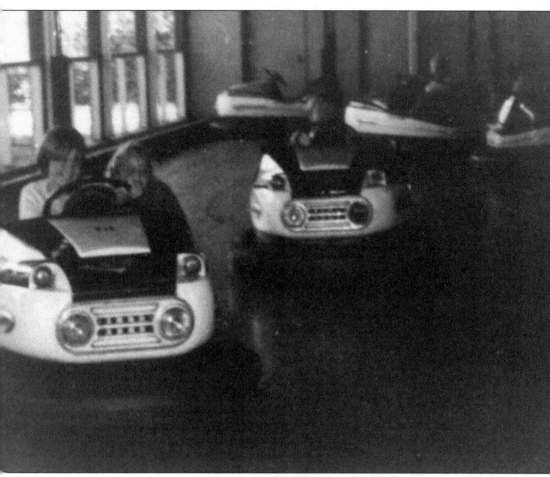

One of the old favorites at Americana was the Dodgem ride, where riders could take aim and run into any car they wanted to. It was one of the original rides installed in the park in 1925 next to the carousel. The cars were updated over the years, with at least four different versions documented. In May 1988, an electrical short inside the structure that covered the antique carousel caught a bird's nest on fire, resulting in heavy damage to the carousel. The fire quickly spread to the Dodgem building. Park owner Howard Berni credited the ride operators with a quick and efficient evacuation of both rides and for keeping children away from the area while firefighters put out the blaze. Both rides were eventually replaced with smaller versions. (Jim Ewen.)

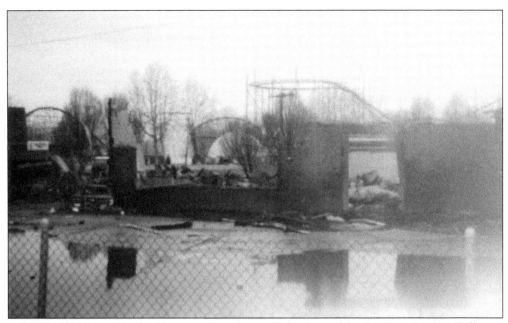

In January 1990, an electrical fire started underneath the floor of the Stardust Gardens Ballroom and spread quickly to engulf the bathhouse and a number of concession stands, destroying parts of several rides being stored for the winter. This photograph shows the remains of part of the arcade and first-aid station just off the main entrance. (Wade Back.)

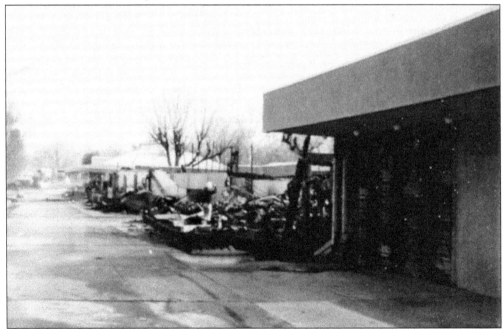

The original bathhouse was built in 1934, and the ballroom construction followed shortly after. The dried-out wood fed the fire and helped destroy the brick facades facing the midway. The structure to the right that was partially damaged was a games building. The building in the background with the large roof was the gift shop and restaurant, which went undamaged except for some of the roof melting due to the intense heat. (Wade Back.)

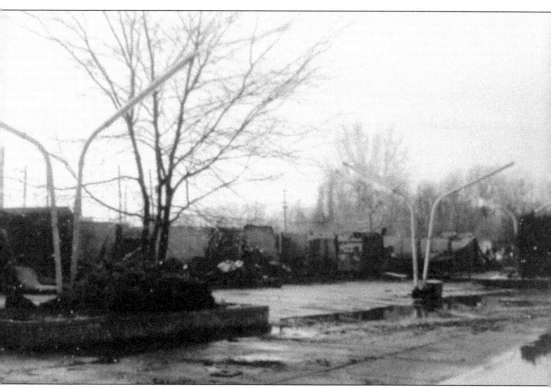

The concrete walls separating the food concession stands from the bathhouse were the only survivor of the fire. Ironically, the walls were installed in the 1934-era structure to help prevent the spread of a fire. Since the park was closed at the time, there were no injuries to guests, and staff working at the park were not in the immediate area when the fire started. Americana's insurance covered up to $5 million; however, damages were much higher, and the park was forced to cover some of the loss. Within weeks, the bathhouse area was rebuilt into an open-air food court featuring Skyline Chili. A demolition derby ride was purchased, and the Flying Scooters were moved to an area next to a new outdoor food court. Americana management credited the local labor unions' cooperation with getting paid on a delayed basis as the park made every effort to open on time for its preview weekends in May. (Wade Back.)

*Three*

# OWNERSHIP SHIFTS SHAPE THE FUTURE

The bathhouse fire forced Americana to go into bankruptcy by the end of 1990. The park's insurance company did not pay off the full amount of the claim, leaving the park short of cash to pay off construction costs. Americana also ran into issues with the same labor unions that helped it reopen when park officials implemented a program to bring Mexican students to the United States to work at the park during the summer to gain practical and language experience.

Americana constructed a dorm outside the main gate in the parking lot and became the summer home for the students. The students began reporting complaints regarding their living conditions and wages to the media and state officials. A number of labor unions cancelled their annual group outings at the park. This resulted in a drastic reduction of income and contributed to the park's bankruptcy.

In the spring of 1991, a group of Americana management consisting of Joe Faggionato, Guy Sutton, Don Robison, and Leonard Gottstein bought the park. Faggionato's father, Lou, was a former owner of the park's games. Sutton was Howard Berni's son-in-law and worked in sales. Robison was also Berni's son-in-law, and Gottstein had previously worked as the park manager.

Sutton left later in the year to take a position at a New Jersey amusement park, but the trio continued and brought the average attendance back to around 500,000.

Americana opened for the holidays for the first time in its history when it launched the "world's largest free Halloween party." Unfortunately, the new owners had the knowledge and energy to operate Americana but could not generate enough income to bring in new attractions and plan for the future. In 1995, Americana was offered for sale and a buyer was quickly found right around the corner.

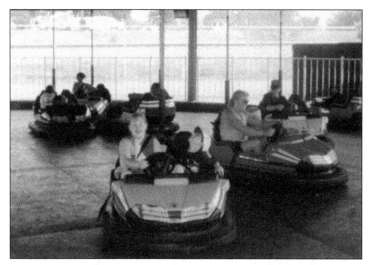

A new version of the demolition derby was added after the 1990 fire and was located just inside the main entrance gate. Heather Morris (left) and her sister Heidi Morris take the new cars for a spin. The ride was removed after the 1999 season and never replaced. The swinging ship took its place on the midway when the park reopened in 2002. (Heidi Noelle Morris.)

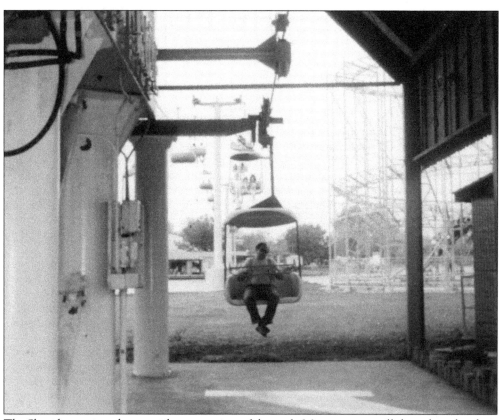

The Skyride continued to provide a great view of the park. Most guests recall that when the chair rolled over the guide rails at each support pole, it would tend to rock slightly. The ride began having maintenance issues in the early 1990s. State ride inspectors and a private consulting firm said that an unoccupied car fell in June 1990 because a sheave wheel supporting the gondola suddenly went too high, causing the cable to go out of alignment. (Heidi Noelle Morris.)

Americana hired an outside firm to handle its marketing with an inside person. Former Americana vice president Bill Robinson left the park in 1983 to open his own marketing firm dedicated to small and medium-size amusement parks. In 1991, his firm was selected to represent Americana. This marketing folder contained group outing information. Ironically, Robinson represented Fantasy Farm in the late 1980s before the park closed for good in 1991. (WHR Inc.)

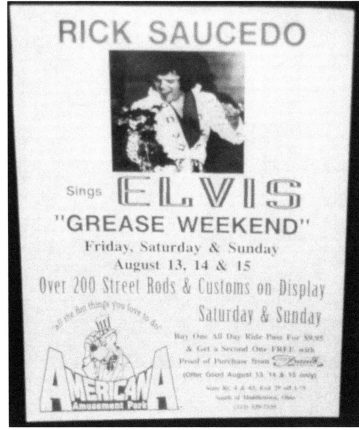

The last appearance of Elvis tribute artist Rick Saucedo occurred in August 1994 during a custom car and hot rod show. Grease Weekend was an attempt to get back to the basics that used to bring in more guests. Although the park never released attendance figures, it was estimated that annual attendance was 320,000. (WHR Inc.)

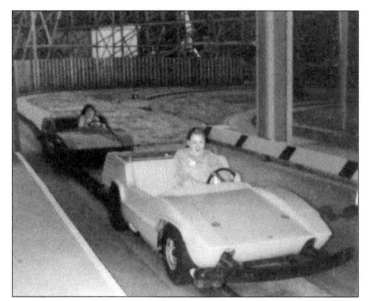

The Italian Speedway cars remained popular. In this image, Heidi Noelle Morris is all smiles pulling into the loading station. These Speedway cars replaced the Streco cars and were used through the 1999 season. A couple of these cars may be resurrected as part of the new recreational park offerings. (Heidi Noelle Morris.)

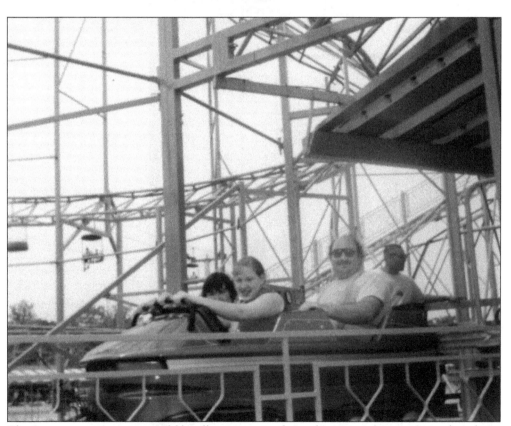

The Serpent was Americana's fifth roller coaster in the park's 80-year history. It was bought in 1989 from Noble Park Funland in Kentucky and was a hit from the start. Heidi Noelle Morris gets ready to experience the figure-eight track. The purchase of this ride was timely, as Coney Island did not have such a ride and Kings Island had recently sold its version. (Heidi Noelle Morris.)

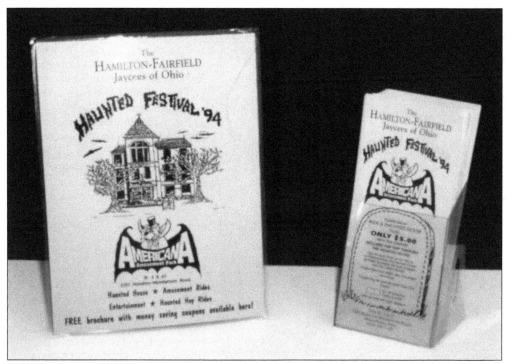

In 1993, the park held its first holiday event on Halloween weekend. Americana was the only amusement park in the tri-state area that hosted a Halloween event. Kings Island did not launch its Halloween events until 2000, and Coney Island did not have similar events until about 2008. (WHR Inc.)

The Hamilton-Fairfield Jaycees of Ohio moved its fundraiser to Americana after spending several seasons at Fantasy Farm Amusement Park in the mid- and late 1980s. The Jaycees supplied the volunteers to perform each night while Americana added a haunted hayride. The Jaycees held its 1994 and 1995 fundraisers at the park. (WHR Inc.)

Sometimes getting on a ride gets old. In that case, Americana always had a variety of animals to climb on, including this giant tortoise in Kid's World where Joe Tallarigo (left) and his brother Keith find time to continue their play. The building in the background was transformed into a new locker area to serve swimmers after the bathhouse fire in 1990. (Mary Ann Tallarigo.)

It is splashdown time on one of the many Hampton rides in Kid's World. Bradley Scott (left) and his sister Marissa Omilakin enjoy a spin in one of the many Hampton-brand rides scattered throughout Kid's World. The area also featured a Mommy's Timeout rest area, a child-size carousel, and a Ferris wheel. (Susan Omilakin.)

*Four*

# NEW OWNERS CLOSE PARK

Cincinnati's Coney Island, which itself had been relegated to the history books in 1971 when it closed, made a resurgence as a full-fledged amusement park in the 1980s and bought Americana in the winter of 1996. Americana's new president, Ronald Walker, sought to carve Americana into a northern version of Coney Island in an attempt to grab the lucrative group outing market from Kings Island. In 1998, Ronald Walker unexpectedly passed away, and his wife, Brenda, took over park operations. She did not agree that Americana could be an asset and put the park up for sale. The park continued to run normally through the 1999 season when Coney suddenly announced that Americana would not open for 2000. A stipulation was that if a buyer could not be found, then the park would be dismantled, and all of the rides would be auctioned off.

In May 2000, local camper sales owner Jerry Couch announced that he had bought Americana and began developing plans for a year-round operation. Renovations were started on the gift shop and restaurant building, located just inside the main gate, and in Kid's World.

In 2002, Couch opened the park with a name change back to LeSourdsville Lake. He hired a group of former carnival managers to run the park; however, that partnership failed that August, and the park was closed. In the meantime, Couch moved his New Miami camper sales dealership into the showroom building, erected a substantial addition that became an exhibit area, and added showroom space.

Several rides from Kid's World and the metal support structure from the old circus tent were moved onto the Fantasy Farm property.

In 2006, Couch bought the former Fantasy Farm Amusement Park site with the expectation of turning the area into a campground to accompany his camper sales business. He said that he wanted to operate the only camper sales dealership in the United States with its own amusement park. Couch could not obtain the needed zoning change, so he announced that Americana would not reopen and that the rides would be sold.

In February 1996, the parent company of Coney Island, Park River Inc., bought Americana and immediately changed the park's official colors to purple, teal, and green. Many of the managers formerly at Coney Island were brought in to manage Americana. The iconic entrance sign on State Route 4 was repainted, and the flags flying over the entrance gate shown here were replaced. An aluminum horse carousel was installed just inside the gate area along with a new demolition derby ride; in addition, rides dedicated to smaller children were established. An aggressive regional advertising campaign involving billboards and print media reflecting the reimagining of the park was visible around the Cincinnati and Dayton area. The ads were entitled "Why Wait" and focused on the fact that guests would not have to wait in line for their favorite rides, compared to the long waits reported at neighboring Kings Island. (Monroe Historical Society.)

This print ad in a coupon book sent to millions of residents in the region featured Americana and Coney with the same opportunities and separate discounted admission coupons. Coney Island and Americana had similar attractions and rides and targeted many of the same group outing customers. Park River's advertising objective focused on targeting the lucrative group-outing business at Kings Island. (Monroe Historical Society.)

One ride that Coney Island did not have was the Screechin' Eagle roller coaster. Fresh from a visit from the Roller Coaster Club of Great Britain, the coaster remained the prime attraction at Americana. Tom Rhein, vice president of Americana during the Coney years, is a prolific amateur photographer who captured a variety of images of the Screechin' Eagle during his tenure. (Tom Rhein.)

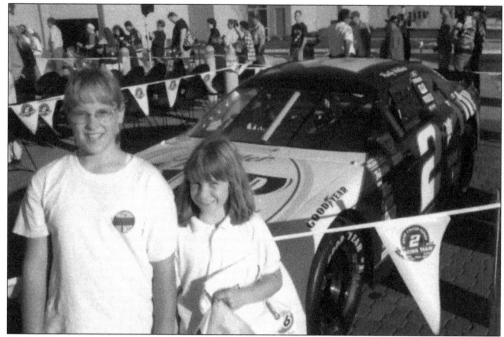

NASCAR driver Rusty Wallace toured the country with his No. 2 car and made Americana one of his stops in 1997, as seen here with Sarah (left) and Tracy Fowler. This was the first and last time that a NASCAR driver appeared at Americana. Wallace was in Ohio before racing in the Brickyard 400, where he finished 38th after developing engine trouble. (Monroe Historical Society.)

While the new color scheme was used extensively throughout the park, including on the food court towers on the left and the carousel on the right, Park River's president Ronald Walker died, and his wife placed Americana on the market. Several existing amusement park companies expressed interest; however, Park River knew Americana could be profitable and did not want to sell the park to a potential competitor. (Monroe Historical Society.)

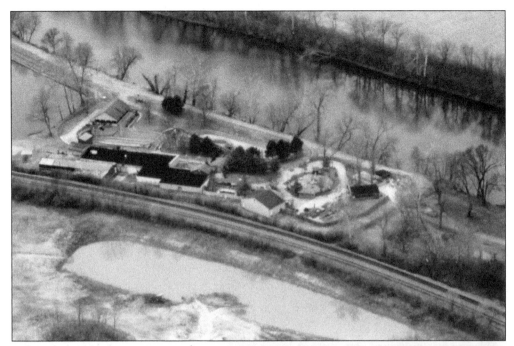

In January 2000, it was announced that Americana would not open for the season. Americana was eventually sold to Jerry Couch in May 2000, but the park remained closed until June 2002. This rare aerial view of Tombstone Territory (Logger's Run) shows the saloon in the lower left, the Raging Thunder Log Flume in the middle, and the Great Miami River at the top. (Robert Lee Curtis.)

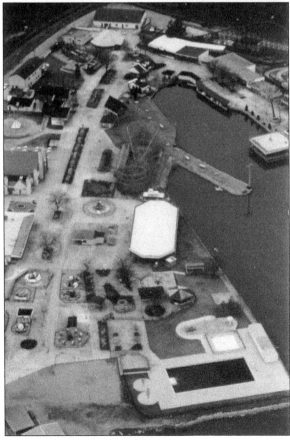

The shuttered midway is shown here with the swimming pool at the bottom, the Serpent roller coaster in the middle, and the Screechin' Eagle roller coaster at top. During the winter, ride cars, tents covering rides, tables, and chairs were removed from the midway and placed in storage until spring, when they were cleaned, repaired, and repainted. (Robert Lee Curtis.)

Renovations to the park were begun in 2000, including a new safety fence in Kid's World and a renovated restaurant, but a reopening date was never announced. The author developed a mini-museum in his home with a vast collection of memorabilia that inspired him to make plans for a book. Although the museum was never opened to the public, it was featured in the *Cincinnati Enquirer*. (Monroe Historical Society.)

In 2002, a newly painted entrance sign and 10 new rides awaited an eager crowd. The most noticeable change was a name change back to LeSourdsville Lake. The park was originally going to be called the "Great American Amusement Park at LeSourdsville Lake," but the owners of Great American Financial Company, owners of Coney Island, objected. LeSourdsville Lake also operated on a reduced schedule of Thursdays through Sundays, and no group outings were scheduled. (Kevin Miller.)

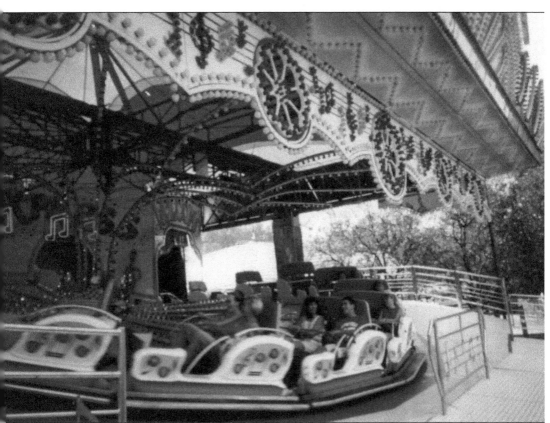

The Music Express was just one of 10 carnival rides that were leased by the park's operator, the LeSourdsville Group. Other new attractions included a fun house, a swinging ship, the Western Express Train, a bumper car ride for children, a Zipper, and a teacup ride. All of these rides were repossessed at the end of the season after the park operator went bankrupt and failed to pay employees. Most of the permanent rides were sold to undisclosed buyers. The park's Ferris wheel returned to the midway in 1998 after a 30-year absence. The ride was purchased used from an unknown source and was sold in 2006 to an unknown buyer. (Monroe Historical Society.)

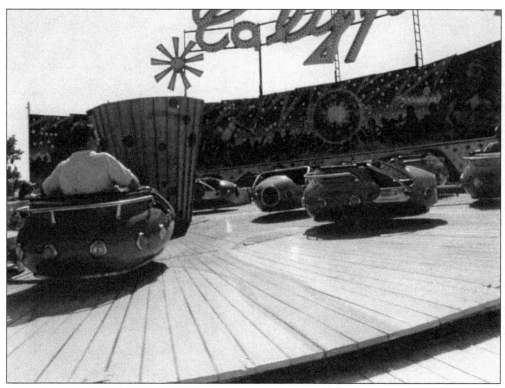

The Calypso was not one of the new rides brought in, but it did receive a very much-needed paint job. It is similar to a Scrambler except it is on a constant tilt. This colorful ride has been a midway favorite at LeSourdsville Lake since 1972. It is actually one of only about a dozen left operating or in storage. The ride was sold to the Funspot in Angola, Indiana, in 2003. (Kevin Miller.)

This photograph was taken in 2002 when the Scrambler was operating in Tombstone Territory (Logger's Run). It has been operating at LeSourdsville Lake since 1961. After the park closed in 2002, it is not known who purchased the ride. The ride is found at just about every amusement park and carnival operating today. (Kevin Miller.)

The fun house was not very fun-looking during the day, but at night, it resembled the lighted buildings along the midway that reflected well in the adjoining lake. Most of the carnival rides brought in during the 2002 season were not permanently installed, and the midway helped create a carnival atmosphere. (Kevin Miller.)

The park's carousel was nowhere near as large as the original carousel lost in the 1988 fire, and it ran with aluminum horses. The steel shelter was moved from the demolition derby ride that was removed after the 1999 season to help protect the carousel. The temporary buildings on either side of the carousel were brought in and added to the carnival-type atmosphere. (Kevin Miller.)

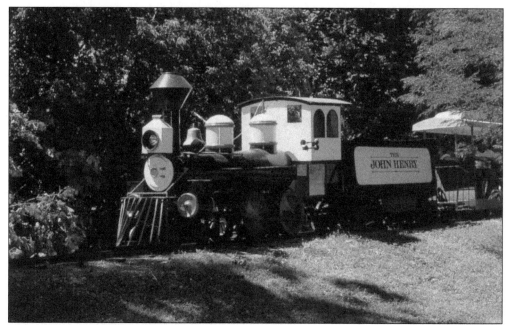

It is not known how many guests rode the Iron Horse since its debut in 1964, but many remember the clackety-clack sound and a slight sway back and forth. The Iron Horse train ran during the last season after it was given a much-needed paint job. After the park closed in 2002, the ride sat in the loading station for years until being sold to an unknown buyer. (Kevin Miller.)

The Flying Scooters were one of the oldest rides still running at LeSourdsville Lake and had a very strong following from a fan enthusiast group. The LeSourdsville Lake version was always a destination for swinging-planes fans since its debut in the early 1940s. Enthusiasts with some experience snap the cables that support the car and throw the car out of its normal motion for a more "out-of-control" ride. (Monroe Historical Society.)

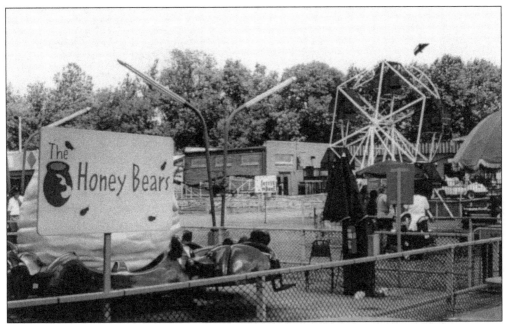

The Honey Bear ride, one of the new kiddie rides added in 2002, was a colorful addition to the area, with its yellow beehive and bees in the center. The ride was a hit with children who did not have a fear of bees. Other improvements to Kid's World included new plastic fencing to replace the rusted metal fence. (Kevin Miller.)

Although the ride was called the Mini Indy, it was basically a demolition derby for small children. This carnival version was brought in as part of a ride package by the LeSourdsville Group. The ride, along with 10 others as part of that package, was repossessed after the management group went bankrupt. (Kevin Miller.)

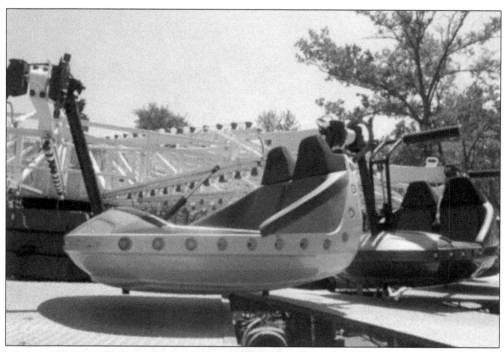

One of the few rides purchased by owner Jerry Couch was the Skysurfer. Few people knew of the ride because it was the only one ever to be installed but never operated. By the time it was ready to be inspected and opened to the public, LeSourdsville Lake was shut down after problems developed between Couch and the LeSourdsville Group. (Kevin Miller.)

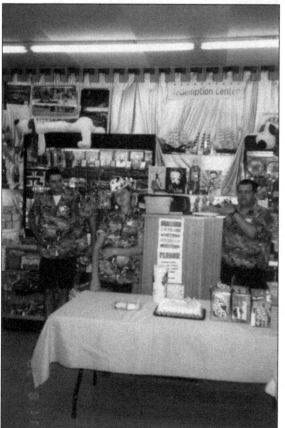

This photograph was taken inside the Fascination building on the last day the park was open in 2002. Little did these employees know that this would be the final time they would call out the infamous Fascination welcome greeting or work at LeSourdsville. Couch lost millions of dollars operating the park, abruptly closed it, and continued operating his camper sales business. (Jim Ewen.)

# Five
# PARK EMERGES AS A MEMORY

Between 2006 and 2009, LeSourdsville Lake remained dormant, and rides were sold intermittently or stored inside semi-trailers. In August 2011, the Screechin' Eagle was unceremoniously torn down without any advance announcement. Couch's reputation in the amusement park community soured very quickly due to his lack of communication about what was left of the park.

Over the years, Couch's Camper Sales flourished, even with the shadow of the former amusement park lingering nearby. Couch would tear down a building when it became a safety hazard, as he did with the roller coaster. It was clear that LeSourdsville Lake would never become an amusement park again.

Couch announced through the media in 2006 that LeSourdsville Lake was closed permanently and that all remaining rides and attractions would be sold.

In 2016, Couch closed down his camper sales business and retired. While rumors around the community suggested that the former park would be put up for sale, there was some behind-the-scenes negotiating going on with the City of Monroe and Butler Tech, a vocational school dedicated to high school students and adult learners with multiple locations in Butler County.

In 2017, Butler Tech announced that it had bought the 36 acres that Couch's Camper Sales occupied and the Fantasy Farm amusement park property, with the exception of the motel and restaurant building to use as a future campus. Couch donated the LeSourdsville Lake land consisting of just over 50 acres to the City of Monroe. Monroe quickly accepted the donation and began developing a master plan for the amusement park land as well as the existing city parks.

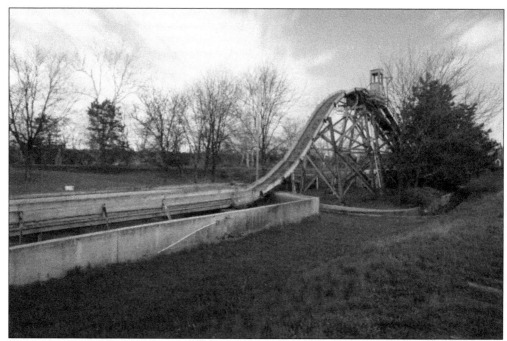

A ride such as the Raging Thunder log flume could not be duplicated at another park because of the terrain the ride rests on. The log cars were another story. They were sold or given away to people in the area and show up from time to time at flea markets or antique malls. (Ronny Salerno.)

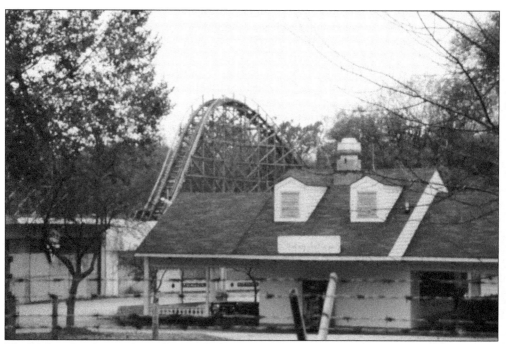

The Midway Ice Cream shop, along with the game building and gift shop in the background, are boarded up. Couch was seeking a new management company to run the park; however, he was unable to come to terms with any company and kept the park closed. (Kevin Miller.)

Only the south end of the parking lot serving LeSourdsville Lake was used for Couch's Camper Sales. The media routinely linked any news about Couch's Campers to LeSourdsville Lake. When Couch sold the buildings connected to Couch's Campers, the headlines read that Butler Tech had purchased LeSourdsville Lake. However, Butler Tech had only purchased Fantasy Farm and LeSourdsville's parking lot. (Kevin Miller.)

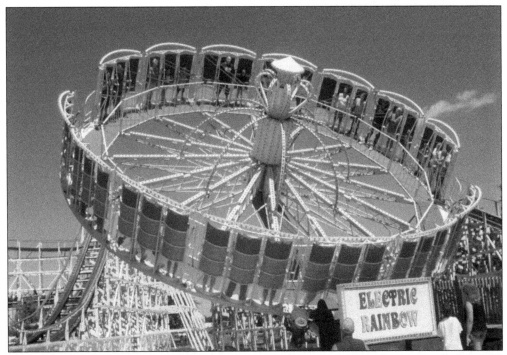

The Electric Rainbow was one of several spinning rides at Americana. It was installed in 1977 and always experienced long lines. Although only about 70 were produced in the United States, similar versions could be found at Kings Island and Coney Island. In 2006, the ride was sold to Stricker's Grove near Cincinnati, where it continues to operate today. (Author's collection.)

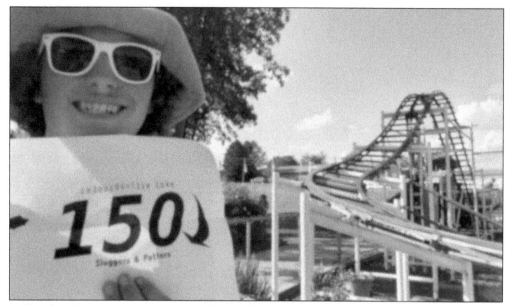

LeSourdsville Lake and Americana Facebook page administrator Thomas Van Horn rode his 150th ride on the Little Dipper in 2020, but it was not in Kid's World. This coaster ran at Americana until 2002 and was then sold to Sluggers and Putters in Canal Fulton, Ohio. This two-loop-circuit steel coaster gave younger riders the confidence to try larger coasters later in life. (Courtesy Thomas Van Horn.)

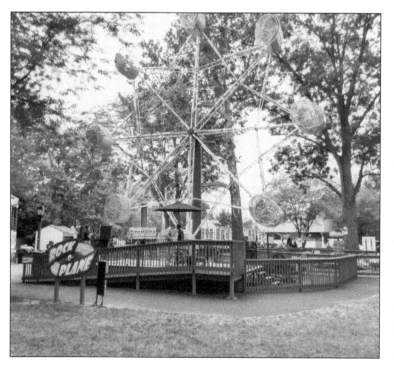

Fans of the Rock-O-Plane did not have to wait long to return to their favorite car to rock and roll. Coney Island bought the ride along with the Tempest in 2000. When Coney sold its rides in 2019, the Rock-O-Plane was sold to an unknown buyer. (Author's collection.)

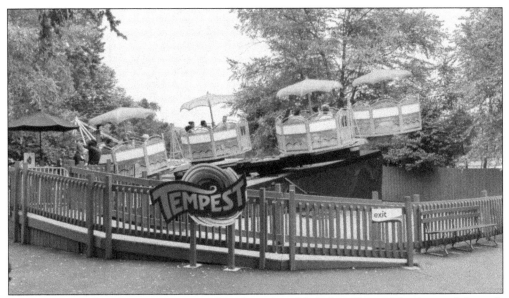

The Grover Watkins Tempest was one of the few rides added when Coney Island owned the park in 1996. The ride ran until 2002 and was sold to Coney Island, where it operated until Coney sold off all of its mechanical rides at the end of the 2019 season. An undisclosed buyer purchased the ride. (Author's collection.)

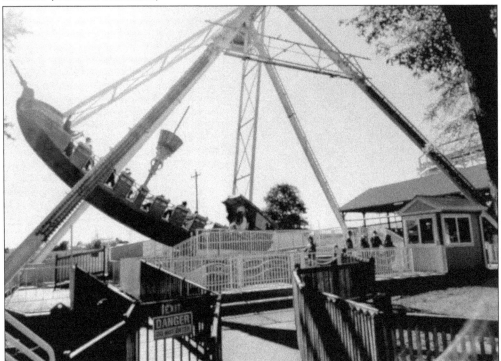

This swinging ship was LeSourdsville Lake's second. The first was installed in Tombstone Territory (Logger's Run) in 1987 and only lasted a couple of years before being removed. This one was sold just months before LeSourdsville Lake closed permanently. The lucky buyer was Stricker's Grove, a semi-private amusement park just north of Cincinnati in Ross, Ohio. (Author's collection.)

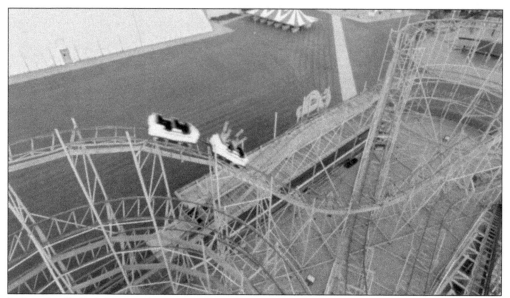

LeSourdsville Lake's second most popular roller coaster, the Serpent was saved from the salvage yard for a third time when Kokomo's Family Fun Center in Saginaw, Michigan, bought it in 2006. It had previously operated at Noble Park Funland in Paducah, Kentucky, before coming to LeSourdsville Lake in 1989. (Kokomo's Family Fun Center.)

John Zibulka of Cincinnati bought a vintage boat from the gasoline version used in the 1970s and 1980s. He altered it to resemble a Chris Craft–brand boat and attached LeSourdsville Lake decals on each side. Zibulka installed a fake Corvette motor over a 20-horsepower Briggs Vanguard engine. (John Zibulka.)

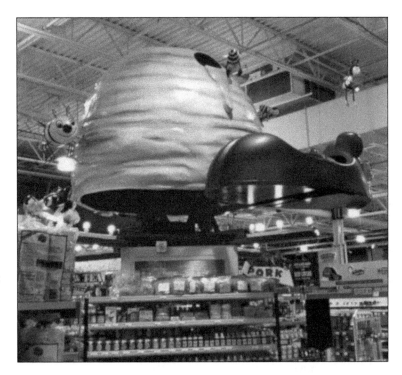

The top half of the Honey Bear ride is now the set display at Jungle Jim's International Market in Fairfield, Ohio. Jungle Jim's has a history of preserving amusement park items. It purchased parts from the Country Bear Jubilee attraction in 1993 and purchased the trams that ran in Kings Island's Safari ride after that attraction closed. (Erik McCullah.)

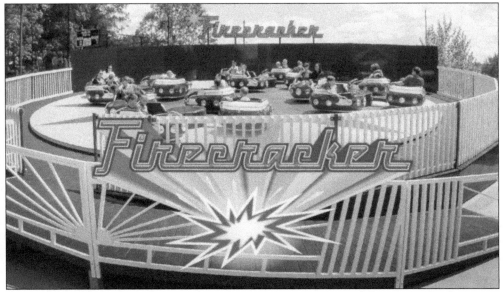

A complete makeover was done on the Calypso after it was renamed the Firecracker by its new owner at Holiday World Amusement Park in Indiana. A lighting package was added to the ride to help it live up to its name. It is known for its "squish factor" and jolting moves as the entire platform revolves. (Holiday World.)

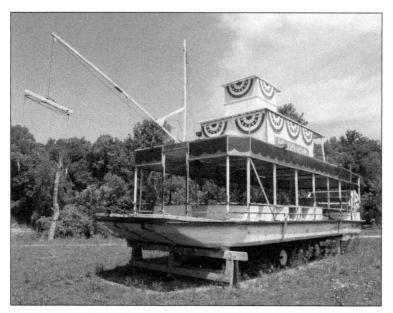

Cincinnati-area photographer Ron Salerno captured the last days of the *Belle of LeSourdsville* as it sat high and dry on the grounds of Fantasy Farm Amusement Park. The boat sat on the property for several years out in the elements, leading to deterioration. It was sold for scrap in 2016. (Ronny Salerno.)

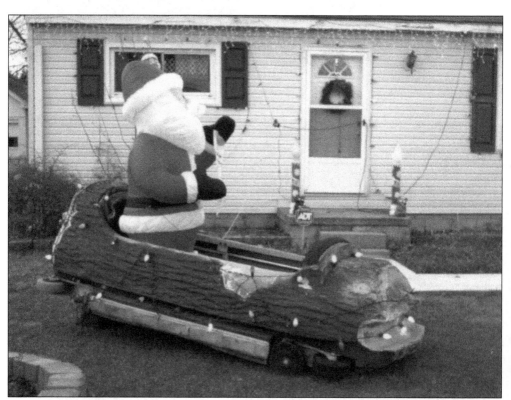

LeSourdsville Lake/Americana enthusiast and memorabilia collector Erik McCullah purchased a Raging Thunder log flume boat several years ago and decided to use it as a Christmas decoration in front of his house. Unfortunately, it cannot be confirmed which Raging Thunder boat was used when the only wedding that took place at Americana occurred on the ride in 1987 between Shelly Matthews and Roger Thomas of Ohio. (Erik McCullah.)

## Six

# THE TRANSFORMATION BEGINS

Just prior to the demolition of what was left of LeSourdsville Lake, the City of Monroe invited selected guests to tour the park, take photographs, and learn what was proposed in the next 10–15 years. Monroe development director Kevin Chesar led a group of about a dozen people consisting of representatives from the Monroe Historical Society and the Middletown Historical Society.

One of the guests was 15-year-old high school student Thomas Van Horn of Liberty Township, who got interested in LeSourdsville Lake because his dad lived across the street and joked about not being able to visit the closed park. When he saw videos of LeSourdsville Lake online, he became an avid contributor on the LeSourdsville Lake/Americana Facebook page. He also appeared before Monroe City Council with a petition against naming the street that feeds into the park in honor of Jerry Couch, who donated the land to the city. Van Horn now serves as the co-administrator of the LeSourdsville Lake/Americana Facebook page as well as the website dedicated to the park, lesourdsvillelake.com.

The city began demolition of the remaining structures in 2018, except for most of the picnic shelters, the Skyride station, a storage building near the Screechin' Eagle entrance, and the administration office building. The city developed potential use ideas from staff and from input from citizens.

In 2020, plans were revealed for the future of the park. Its new name would be Monroe Bicentennial Commons Park and it would include a children's play area, a splash pad, an amphitheater, a fishing lake, walking trails, a museum dedicated to LeSourdsville Lake, and a trail linking portions of the Great Miami River Recreation Trail. Because of the estimated cost of around $10 million, grants would be used for materials and construction, which could take 10–15 years to complete.

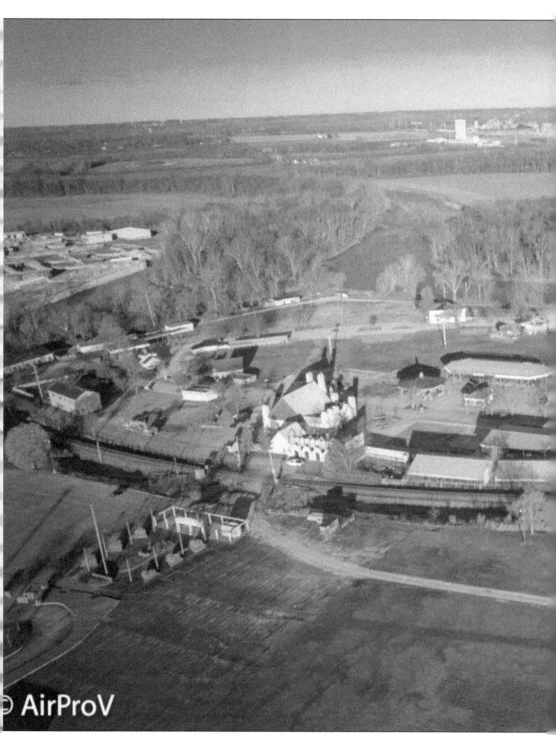

This aerial photograph is the last one documenting the placement of rides and buildings before the rest of the park was dismantled. The Great Miami River runs along the top. The main entrance is at the bottom, with the picnic shelters on the right. By this time, the Screechin' Eagle roller coaster, the Fascination building, Antique Autos shelter, and the restaurant/gift shop at the main

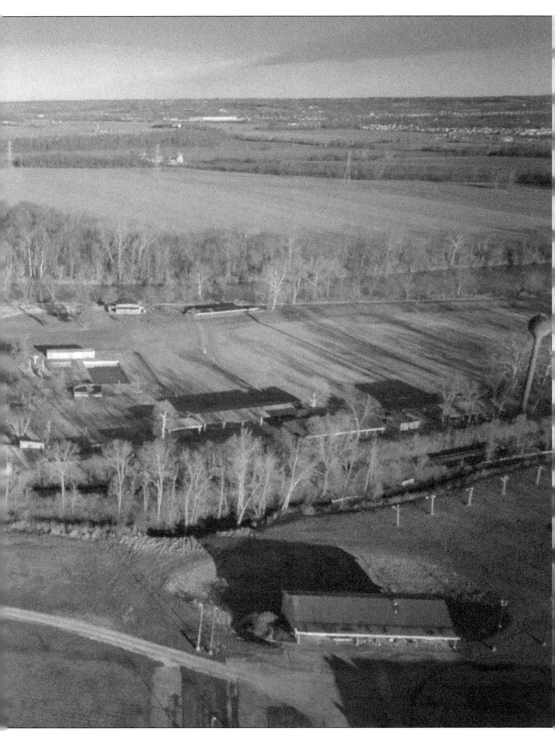

entrance had been torn down. The lake was drained in 2006 after a leak developed and it was not possible to repair it. The City of Monroe saved many items from destruction and will be using them in the future as the recreational park is developed. (A.J. Fullam.)

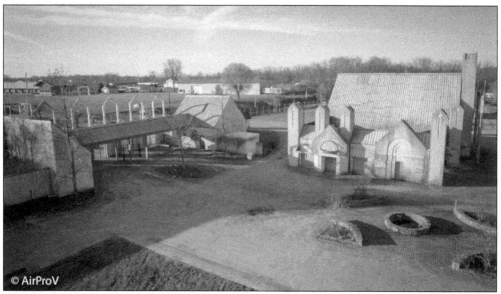

All of these structures were built in 1990 after the ballroom fire destroyed most of this area. The building on the left of the entrance gates was Coffelt's Candy shop, which originally was located in Tombstone Territory (Logger's Run). The structure on the right housed the food court and arcade. (A.J. Fullam.)

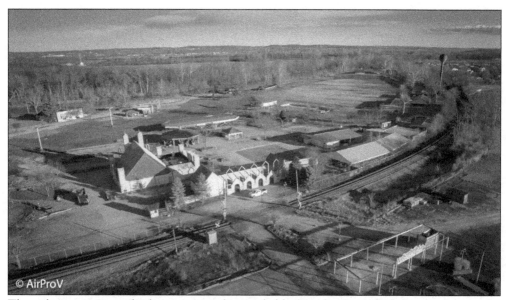

The ticketing gates at the bottom were dismantled before the City of Monroe took over the property. The gate could be seen easily from State Route 4; people would trespass on the property and, in some cases, spray graffiti on buildings or break what few windows had not been boarded up. The Raging Thunder log flume station, at the top of the photograph, adjoins the former lake. (A.J. Fullam.)

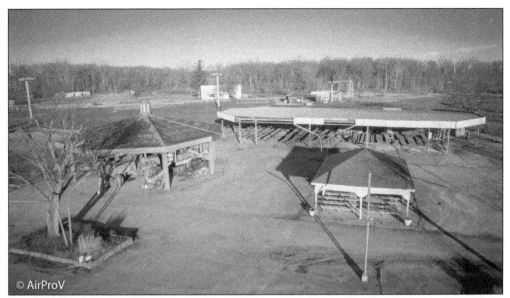

The shelter is where the park's second carousel sat until it was sold. The structure behind the shelter was home to the Indy 500. The building directly in the background was the main arcade. The construction equipment under the shelter was staged there until it was time to tear out several acres of concrete walkways, old water lines, and obsolete electric lines. (A.J. Fullam.)

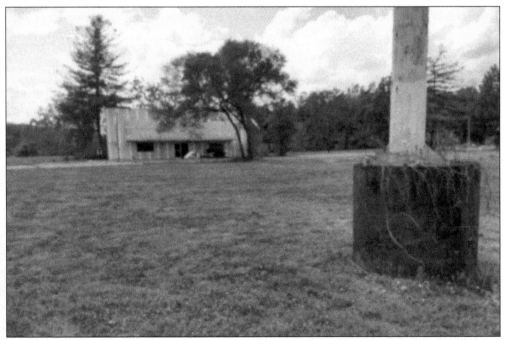

Most of the lake has been filled in. The concrete block in the foreground was one of the Skyride supports. The building in the rear was the main arcade, seen here with remnants of one of the Screechin' Eagle roller coaster cars. The arcade had been heavily vandalized and had not been secured enough to save the building. All of the games had been removed years prior. (Author's collection.)

The building that was once the Food Court was slated for demolition since it was built primarily as an open-air building. It had a small arcade, and one of the spaces served as a mini-museum during the 1992 season. It was built on the site of the bathhouse, which was destroyed by fire in 1990. (Author's collection.)

This metal building was once an award-winning design constructed by Holden Construction in Springboro, Ohio, in 1978. It was originally erected to house the animated show Country Bear Jubilee. In 1998, the building was renamed the LeSourdsville Theater and was home to the Heart of Rock and Roll show. (Author's collection.)

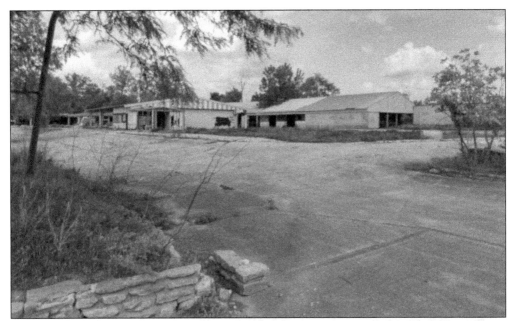

This space served as the catering hub for the park as well as the primary gift shop and the cafeteria. The part of the building still standing served as the green room for stage performers including Chubby Checker, Dick Clark, Boxcar Willie, Billy Jo Royal, Tommy James, Bo Donaldson & the Heywoods, Gayle Watson & Kentucky Morning, Bobby Mackey, Marge Smith, and many others. (Author's collection.)

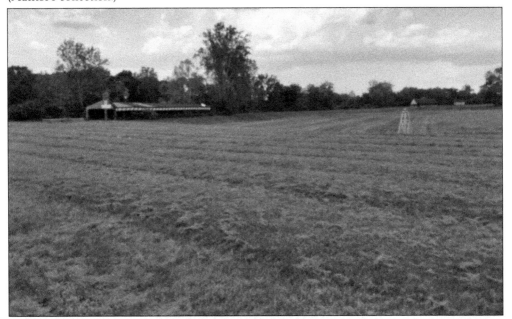

This was the location of the Olympic-size swimming pool looking to the left at the Iron Horse train station. The tower in front was the water buoy, indicating to the showboats to steer clear of the area due to the brick retaining wall that separated the boating and swimming areas. The building in the background was the Raging Thunder log flume loading station in Tombstone Territory (Logger's Run). (Author's collection.)

The midway lighting was reminiscent of what could be found on new highways in the early 1960s. While a number of lamps were damaged after the 1990 bathhouse fire, some were saved and may be able to be repurposed sometime in the future. This view is from the Kid's World area, looking down the main midway toward the Screechin' Eagle. (Author's collection.)

This friendly frog was in the splash pad area next to the swimming pool. Besides fun for the little ones, the frog provided a great place for that special photograph for hundreds of people. Unfortunately, before the frog could be salvaged and preserved, vandals decided to spray graffiti all over it and damaged the frog in the process. (Author's collection.)

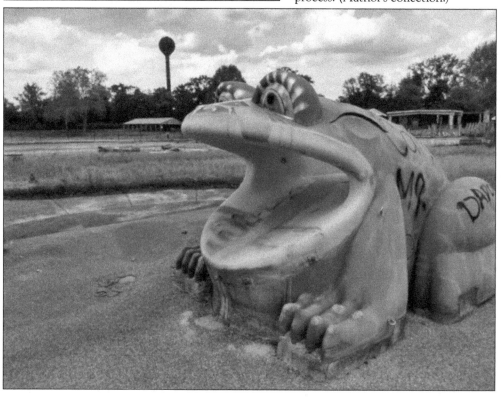

The park's administration building was erected near the site of the original carousel after the 1990 fire. Before that time, lost adults and found children could have been found near the main entrance gate where the office used to stand. The Electric Rainbow also sat in front of this building for several years. This two-story structure is proposed to be part of the new recreational park. (Author's collection.)

This was the site of the Dry Gulch Saloon in Tombstone Territory (Logger's Run). The saloon was known for its country music stage concerts by Ken Roberts and the Country Rebels featuring teen signer Diane Walker. Sagebrush with C.D. Craft was another headliner on the weekends. Both groups were featured live on WPFB-AM from Middletown for years during the 1970s. (Author's collection.)

This Italian sports car from the Speedway ride may become a familiar sight in the new recreational park if the City of Monroe has anything to do with it. The park had hundreds of redwood picnic tables, and most of them were sold before the park was dismantled. Some were destroyed by vandals, as seen in this photograph. (Author's collection.)

This view is from the showboat dock toward the main entrance and the Skyride loading station on the right. This side of the lake was not very deep, so filling it in did not take much effort. The Skyride support poles were only standing in a couple feet of water. (Author's collection.)

This rusted NAD roller coaster car originally ran on the Wildcat at Elitch Gardens in Colorado. When the roller coaster closed in 1994, the cars were shipped to Americana, where they continued to run until 2002. Erik McCullah of Cincinnati owns this roller coaster car that he purchased from the demolition company. The front of the car is on display at the Monroe Historical Society, thanks to the City of Monroe. (Author's collection.)

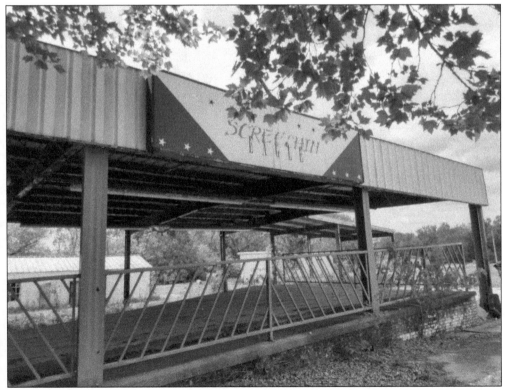

The Screechin' Eagle roller coaster loading station was left intact after the coaster was torn down in 2011. The coaster was originally known as the Cyclone when it was rebuilt in 1940. It originally was built in 1927 and ran at Moxahalia Park in Zanesville, Ohio. The station is not part of any repurpose plans and is merely a steel structure with a slanted wood floor. (Author's collection.)

The main entrance gate changed considerably over the years. This last version was built in 1990 to match the new design of the food court building. Although most employees parked in the main lot with the guests, there was a special gate next to this entrance that allowed some employees to enter the park and drive around the perimeter to Tombstone Territory (Logger's Run). (Author's collection.)

Inside the main entrance, guests found an abundance of concrete walkways and concrete planters during the 1990s. Prior to that, the concrete walkways were broken up with large stone planters that had mature trees to supply ample shade. After Disneyland opened in 1955, the idea of what parks should look like changed, and the park needed to pay as much attention to landscaping as it did to rides and attractions. (Author's collection.)

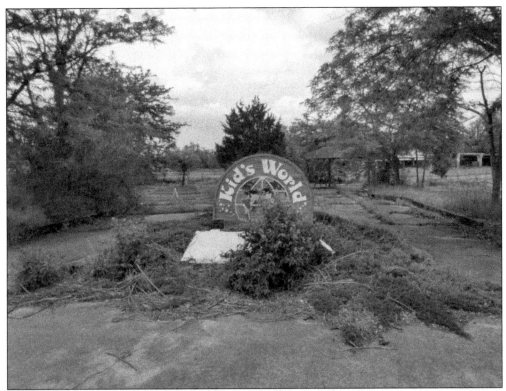

Kid's World served as the training ground for children to gain experience to ride the big rides. During the 1970s, the park had the 17th-largest dedicated children's area among amusement parks in the country. The children's area was originally just inside the main gate on the right. It was later moved to where the stage and Indy 500 were and then to its last location next to the swimming pool. (Author's collection.)

From 1976 to 2002, the swimming pool was a very popular attraction. When the park tried to close down swimming in the lake in 1975 so that it could begin filling in a part of it for expansion, it was met with such strong resistance that swimming was extended until the end of the year. (Author's collection.)

The Skyride loading station has seen better days since it was originally installed in 1965. The 24 open-air cars only ran 60 feet over the lake or down to the train station and back. In 1978, the train station was torn down and moved so that the midway could be extended. The Skyride stayed at its original location and never became an alternative way to get around the park. (Author's collection.)

The main midway awaits a bulldozer to remove the thousands of memories left on the pavement. It is easy to imagine screams and laughter from the Serpent roller coaster, the smell of the Beer Garden nearby, and the aroma of Skyline Chili and cotton candy. (Author's collection.)

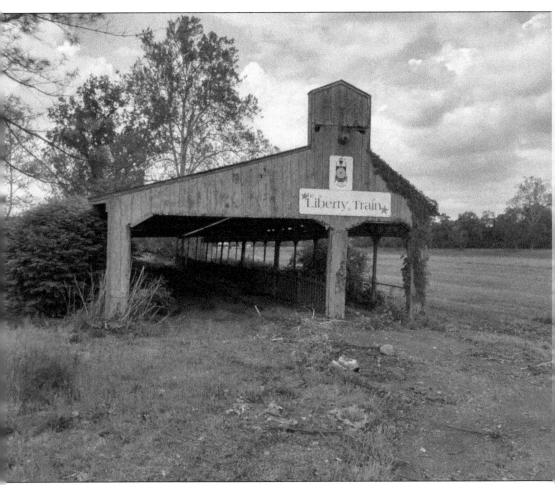

The Iron Horse train station stood along the lake and was built on top of a levee separating it from the Great Miami River. Two NAD trains were designed as replicas of the 1860 Union Pacific Railroad locomotive No. 58. Before this station was built in 1978, the train was Ohio's longest train ride, operating on 4,000 feet of track. The original train station, built in 1964, was near the main arcade. Next to the train station was Americana's most expensive ride ever installed, the Raging Thunder log flume. The flume's designer, Ron Berni, took advantage of the terrain and enabled the flume to take some directions one would not find on a flume otherwise. The land that the flume sat on is a former bird sanctuary. (Author's collection.)

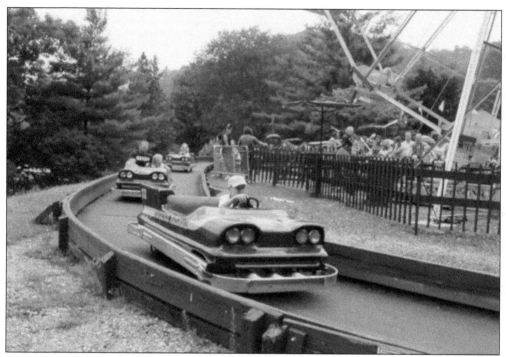

It was 1955 when the first version of the Streco turnpike cruiser made its debut at LeSourdsville Lake. It was manufactured by Edgar Streifthau and Frank Dodd in a building on the grounds of Fantasy Farm. About 14 amusement parks from across the country used the car, which proved to be durable and unique-looking. Tweetsie Railroad in North Carolina continues to use the cruisers since buying them in the early 1960s. (Tweetsie Railroad.)

Tweetsie Railroad is the only amusement park in the United States still running Streco turnpike cruisers. Streifthau's company, Streco Manufacturing Inc., went out of business in the early 1970s but managed to produce 167 cruisers. All of the cruisers were delivered personally either by Streifthau or his son Lindy. Streco also made a variety of amusement park–related items, including fiberglass chairs and picnic tables still found in the Ohio area. (Tweetsie Railroad.)

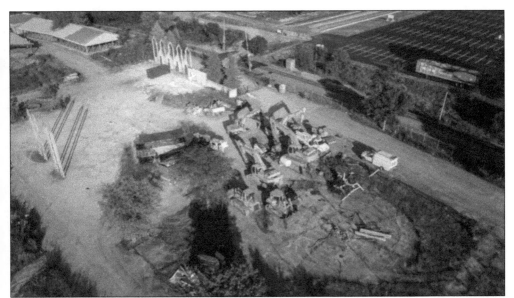

Bulldozers finish grading land that used to house the food court (where the two tall towers are standing) and the entrance gate. The towers that stood in front of the food court and the main gate were planned to be repurposed; however, they were unable to be saved due to their deteriorating condition. The round-shaped area was the home to the Flying Scooters. (Ronny Solano.)

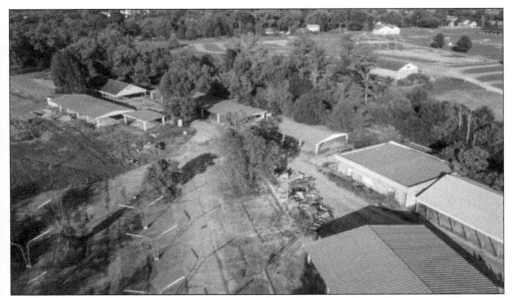

The area in the lower-left was part of Kid's World. The area to the right was torn down and included two picnic shelters, an old set of restrooms that were converted to a bathhouse after the 1990 fire, and newer restrooms. The midway lighting seen in the lower left was salvaged and may be repurposed. The remaining shelters will be used as part of the new recreational park. (Ronny Solano.)

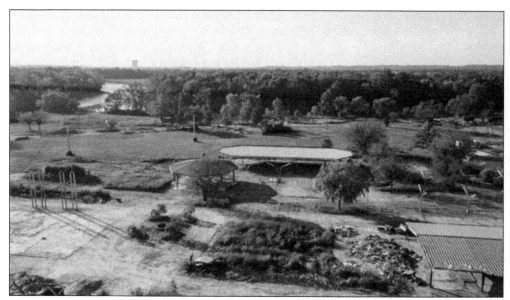

The area in the foreground used to be home to the restaurant, gift shop, hat stand, and green room for the stage performers. The photographer offers a glimpse of what the new recreational park will have to offer, including a spectacular view of the Great Miami River along a paved walkway. With the exception of the shelter in the middle of the photograph, all of the structures and concrete were removed. (Ronny Solano.)

This was the deep end of LeSourdsville Lake. The middle part of the lake contained a retaining wall that helped support diving platforms. The original size of the lake was 18 acres, but it was filled in over the years to allow for more rides. The beach area was to the left. In anticipation of leasing part of the park to a church, Jerry Couch filled in the middle of the lake with a land bridge next to the retaining wall. (Ronny Solano.)

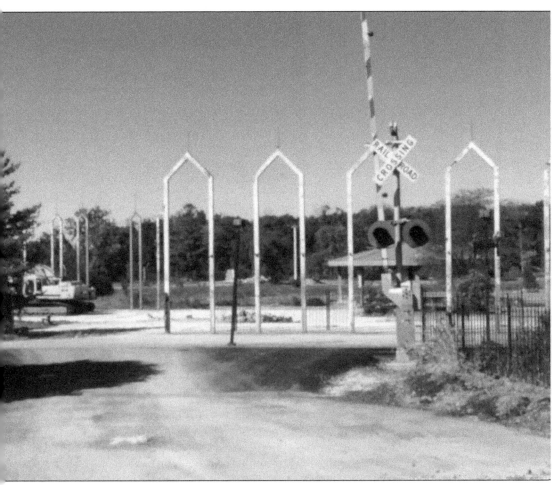

The Norfolk Southern railway that ran through the park's entrance will continue to see trains run through the entrance into Bicentennial Commons Park. What will be missing are the hot, molten steel railcars that ran from the old ARMCO plant in New Miami to the Middletown Works that would emit heat as they slowly went up the track. All of the concrete that made up the midway was removed to the former Tombstone Territory (Logger's Run) area and was recycled into material that will be used to make walkways in the new park. The City of Monroe kept some park memorabilia that is proposed to be repurposed in the park as well. (Erik McCullah.)

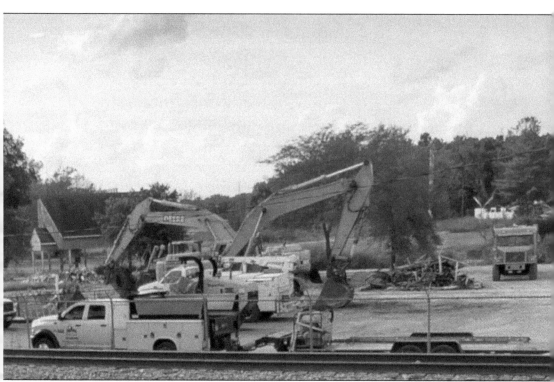

Demolition of the park concluded in 2020 with the removal of the buildings and walkways in Tombstone Territory (Logger's Run), and all buildings and walkways with the exception of a maintenance building and the administration building. In the meantime, the City of Monroe sought opinions from residents on what they would like to see constructed on the site. The result is similar to a wedding: something old, something new, and something borrowed. The most iconic remanent left was the entrance sign that rested along State Route 4. This sign was originally installed in 1958 and altered in 1978 to accommodate the name change to Americana. It was removed in 2018, and part of it is in storage in an undisclosed location near Dayton. The sign was torn down to accommodate a new driveway to service Butler Tech and Monroe Bicentennial Commons, and because it violated zoning regulations for being too close to State Route 4. (Author's collection.)

# Seven
# LeSourdsville Arises

The dust had not even settled after the demolition of LeSourdsville Lake and Americana when Jacquelyn and Josh Van Lieu opened the Fantasy Diner on the grounds of Fantasy Farm Amusement Park. Part of the décor is dedicated to Fantasy Farm, but it also has memorabilia from LeSourdsville Lake. Meanwhile, the City of Monroe hired Brandstetter Carroll Inc. to assist in creating a master plan for the city's park system, including Monroe Bicentennial Commons. Initially, the plan for the former amusement park includes nine themed areas with a central entrance plaza. One area would provide an interactive play area with a fountain, playground, nature play area, and picnic shelters. Another area includes the extension of the Great Miami River Recreation Trail through the property. A riverfront area with swings, a canoe and kayak launch, and an overlook plaza would be constructed along the Great Miami River. One area would be dedicated to a restored nature area with walking trails, a picnic area, and educational features. An amphitheater is also proposed next to a large lawn for special events. Other dedicated areas proposed include the restoration of 7.5 acres of LeSourdsville Lake with canoe and paddleboat rentals. A bird sanctuary and nature habitat and wetland area with an outdoor education center are also planned. Another proposal would include a pavilion area that would repurpose several of the old picnic shelters to accommodate large gatherings, and a game plaza. A small museum dedicated to LeSourdsville Lake and Fantasy Farm is also projected to be part of the park.

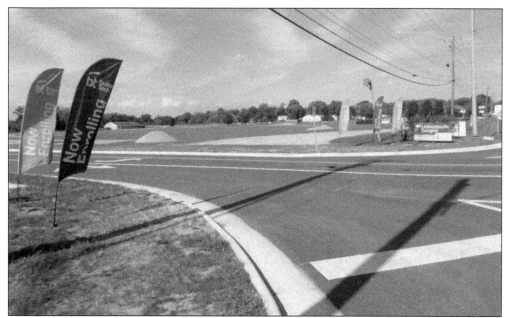

With the iconic LeSourdsville Lake sign gone, a new drive was created to serve Butler Tech and Monroe Bicentennial Commons. With some controversy, Monroe City Council approved naming the road Jerry Couch Boulevard in honor of Couch's donation of the LeSourdsville Lake land to the city. Social media was abuzz with alternative suggestions, including naming the street after Edgar Streifthau, Howard Berni, or Don Dazey. (Author's collection.)

This building was constructed in the early 2000s as a sales center and exposition center for Jerry Couch's camper sales business. Couch said in a *Middletown Journal* article, "With the opening of the Couch's LeSourdsville Lake RV Super Center, we are one step closer to fulfilling our ultimate goal of establishing an RV and amusement park combination." In 2018, Butler Tech bought the building and opened its second adult education campus. (Author's collection.)

This building was originally part of Americana's dorms that were built to house foreign students taking part in a work program. When Jerry Couch bought the park in 2000, he remodeled the building for office space and as a merchandise store for his camper sales business. Butler Tech bought the building in 2017 and remodeled it for office space and a student lounge area. (Author's collection.)

Butler Tech repurposed the building and it became home to a number of adult education classes including nursing, medical billing and coding, medical assisting, phlebotomy, nurse aide training, industrial welding, heating and air conditioning, computer-aided design, Microsoft classes, and much more. Ironically, many of the adult students probably returned to LeSourdsville Lake for the first time since they were children. (Author's collection.)

Jerry Couch Boulevard serves Butler Tech and the Monroe Bicentennial Commons, and at one time was the main drive into LeSourdsville Lake. Couch saved Americana from being dismantled by Coney Island in 2000 and told the media that he bought the park to save it and wanted the park to succeed. (Author's collection.)

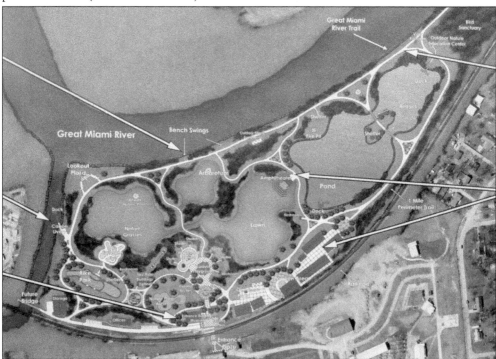

This artist's conception of the completed Monroe Bicentennial Commons is deceptive. Some of the park is being rebuilt using city funds, but the majority of the funding is through grants. In the grant process, the city must adhere to the requirements of the grant and can only spend the funds on particular items. The city has estimated that it could take 10–15 years to complete the park. (Author's collection.)

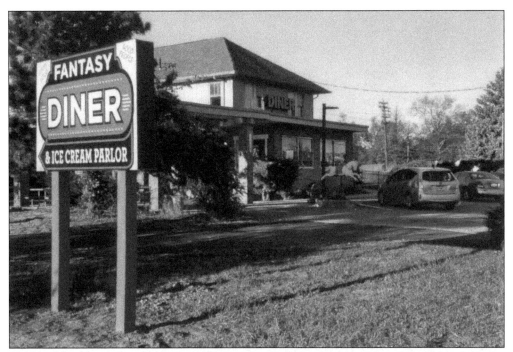

This building served as the home of LeSourdsville Lake founder Edgar Streifthau. After he opened Fantasy Farm in 1963, the building became a motel upstairs and a gift shop and restaurant downstairs. After Fantasy Farm closed permanently in 1991, the home was used for storage. When the property was purchased by Jerry Couch in 2006, he planned to open a restaurant. He did some minor renovations, including an outdoor patio. (Author's collection.)

In 2018, Jacquelyn and Josh Van Lieu bought the building and opened the Fantasy Diner and Ice Cream Parlor. They redecorated the interior and added a variety of LeSourdsville Lake/Americana and Fantasy Farm memorabilia. The exterior features tables from Americana's food court, as well as picnic tables and playground rides from Fantasy Farm. Also displayed are the track lamps from Fantasy Farm's Turnpike ride. (Author's collection.)

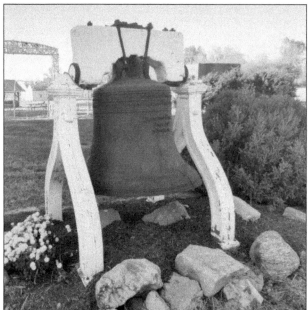

One of the items moved outside the restaurant from Americana was the 1976 Liberty Bell replica. This bell was a centerpiece near the entrance to the Screechin' Eagle and featured an interactive story about the history of the Liberty Bell; it was installed as part of the park's US bicentennial celebration. The Van Lieu family hopes to preserve the bell and move it to a more secure location. (Author's collection.)

In 2020, the Monroe Historical Society opened an exhibit honoring LeSourdsville Lake and Fantasy Farm at its main museum in downtown Monroe. The exhibit had been in storage since 2008 and has quickly become one of the favorite exhibits at the museum. Items consist of parts of rides, over 200 photographs from private and public sources, memorabilia, signs, and a revolving cabinet with gift shop items. (Author's collection.)

The majority of the artifacts came from this author's collection as part of the mini-museum developed in 2001. Other contributors such as Thomas Van Horn, Tom Rhein of Coney Island, Bill Robinson of Americana, Kevin Miller, and Erik McCullah provided items over the years. In addition, the City of Monroe has larger items in storage, and it is anticipated those will be utilized in Monroe Bicentennial Commons. (Author's collection.)

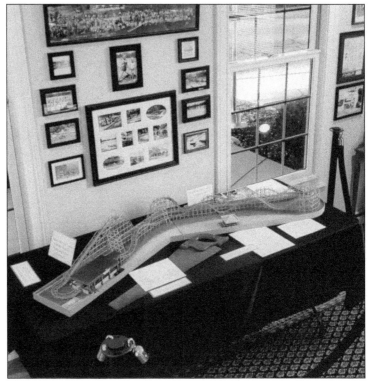

One of the unique items in the exhibit, loaned to the museum by Erik McCullah, is a scale model of the Screechin' Eagle. The model is made of balsa wood. Each piece of the roller coaster was meticulously set and glued together much like an actual roller coaster is built by John A. Hunt of RollerCoasterModels.com. This version is from the mid-1990s and is not painted. (Author's collection.)

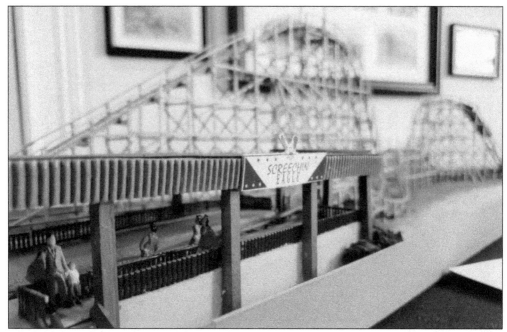

The loading station for the Screechin' Eagle is close to the original but is missing the gift shop building that sat next to the queue line. On that wall was usually a painted logo of the Screechin' Eagle. Unfortunately, the ride is stationary although coaster cars built from plastic or cardboard are part of the model. (Author's collection.)

The steel towers at the entrance gate were kept and were going to be part of the newly designed entrance. Upon closer inspection, the foundation of the towers was in question, and the towers were removed for safety reasons. The Monroe Historical Society received one of the flag posts that were on top of the towers. (Author's collection.)

These towers were just outside the food court and were removed for the same reason as the entrance gate towers. All were installed in 1990 as part of the major renovation after the bathhouse fire. This view is of the former midway with the Skyride building on the right. The park's administration building is on the left, and a maintenance building is in the background. (Author's collection.)

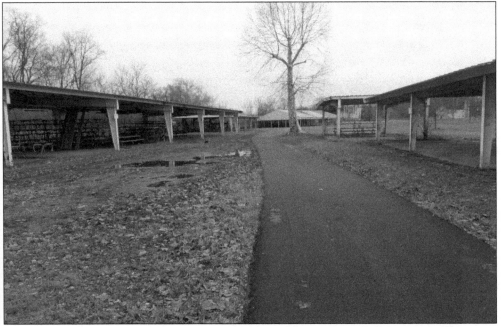

This new asphalt walkway weaves through the old picnic grove along the lake. Most of the picnic shelters were saved except for two near the main entrance. All of the picnic tables that filled the shelters were either sold or destroyed. This walkway will be part of several that will be built around the property and tie into the Great Miami River Recreation Trail. (Author's collection.)

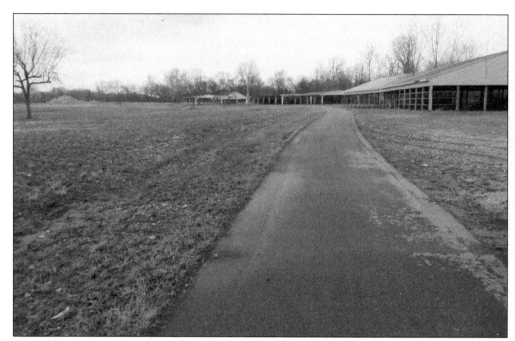

This walkway runs through the former restaurant and gift shop. The city plans to install display signs along all of the trails to describe some of the landmarks that once made up LeSourdsville Lake and Americana. The buildings in the background are the original picnic shelters. (Author's collection.)

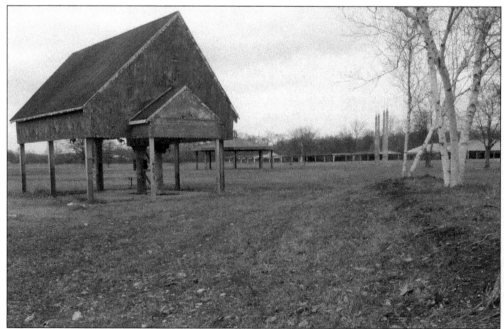

These white birch trees were originally in planters along the original midway and were saved during the demolition. The Skyride building on the left is proposed to become the launch area for a zip-line ride that will most likely follow the same path as the Skyride. A walking path will be installed to connect the Skyride building with the rest of the park. (Author's collection.)

This is the old retaining wall that separated the deep part of the lake from the shallow area. It was used as part of the diving platforms from the 1920s through the 1950s. The wall is very close to a land bridge that was installed by Jerry Couch after the lake was drained. Plans call for an island to be built near this area as a gathering point for guests. (Author's collection.)

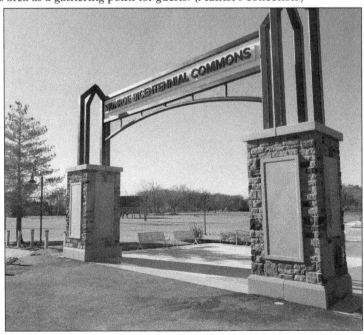

In 2021, the Monroe Bicentennial Commons was opened to the public. A new entrance gateway was constructed where the park entrance gates had been. The towers on either end of the sign are reminiscent of the towers that were torn down. Space is available on the sides of the stone pillars to allow for signage for special events. (Author's collection.)

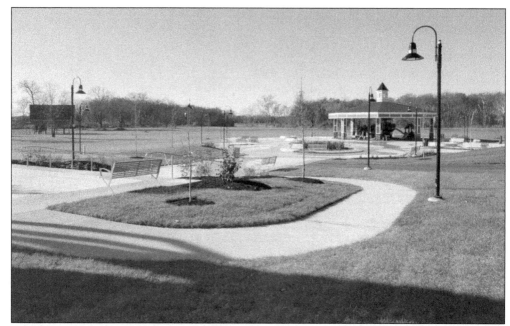

From a nondescript concrete entry, a warmer scene of trees and plants greet guests as they enter through the main gate and head toward the play area for children. There are plenty of seats for older guests who want to relax. The simulated gas lanterns add a nostalgic touch, recalling a time when LeSourdsville Lake was at its peak. (Author's collection.)

This intersection of walking paths rests on the site of the restaurant and gift shop looking toward the lake site. The area to the left of the walkway is proposed to become a fishing lake. The area straight ahead that used to be Tombstone Territory (Logger's Run) is proposed to become a bird sanctuary. Ironically, this same area served as a bird sanctuary during the mid-1960s, when LeSourdsville Lake was competing with Fantasy Farm. (Author's collection.)

It is hard to imagine that this section of LeSourdsville Lake once hosted hundreds of children when it was Pinocchio Land or when the Midway Stage was rocking with national acts or when the Serpent roller coaster was thrilling people of all ages. This luscious-looking lawn will be broken up with a walking trail that will connect to the old Skyride building. (Author's collection.)

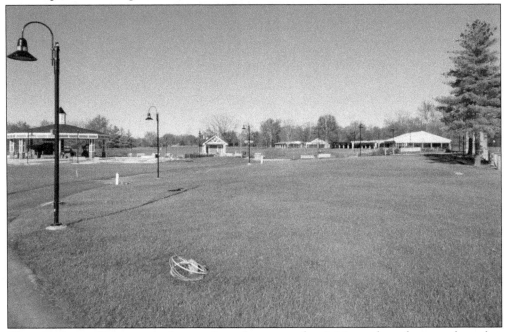

There is plenty of green space for a variety of events and activities such as the space here that contained part of the gift shop and restaurant as well as the park's administration office that was torn down after the 1990 fire. The city attempted to save many of the original trees if they were healthy or not in the way of new utilities. (Author's collection.)

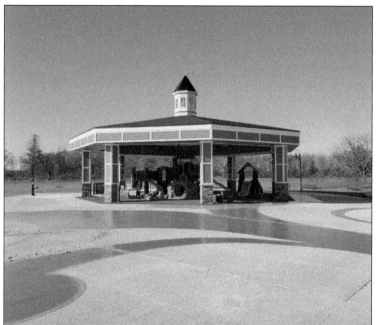

The carousel shelter has been completely refurbished including a new paint job, new roof, and new side panels. Vintage photographs of LeSourdsville Lake will be featured on the panels and will become a conversation piece and serve as a central meeting place. Small shelters will be installed surrounding the carousel shelter. (Author's collection.)

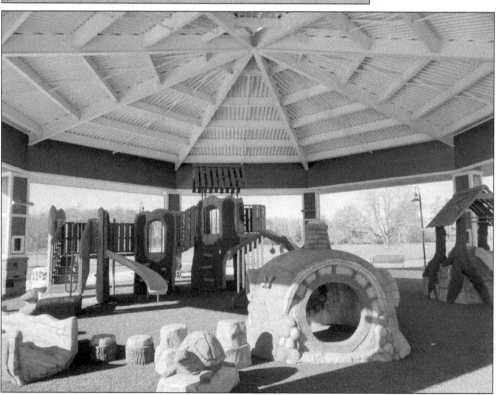

Although the Chance carousel is long gone, sold to an unnamed buyer, the space will be used as a children's play area complete with a slide, climbing units, and smaller climbing units for the very small ones. The ground is covered in soft, green padding that can facilitate wheelchairs. (Author's collection.)

The contour of LeSourdsville Lake is still very visible. This part of the lake will be restored for canoes and small boats, but swimming will not be an option. The concrete steps that led to the Showboat dock are still visible from the walking path. To the right is the area that was home to the Raging Thunder log flume. (Author's collection.)

The area that once was home to the Showboat dock, the Skyride turnaround, the Olympic-size swimming pool, and Kid's World will become an amphitheater. It is projected that the park will become home to not only concerts but large community events, such as Memorial Day picnics and the Fourth of July celebration. (Author's collection.)

The building in the middle of the photograph is a new restroom that sits approximately where LeSourdsville's main kitchen once stood. The kitchen faced the midway, and often, the aroma of some of the over 47 tons of fried chicken annually or 14,000 pounds of baked beans would fill portions of the midway. As Howard Berni once said in a *Cincinnati Enquirer* interview, "Hardly a bean came back uneaten." (Author's collection.)

This wooded area next to the Great Miami River is where the camelback turn was on the Screechin' Eagle roller coaster. The Turnpike track also ran through this area as the home to the Giant Slide. The Great Miami River Recreation Trail will run through here and have swings overlooking the Great Miami River. The towers in the background are part of the Duke Energy Woodsdale Substation. (Author's collection.)

This area was home to the motorboat dock, an ice-cream shop, and the Liberty Bell pavilion. It is slated to become a natural grass preserve along with a walking trail. Additional playground equipment will be installed just to the right of the trees. A splash pad is also slated to be installed near this area sometime in the future. (Author's collection.)

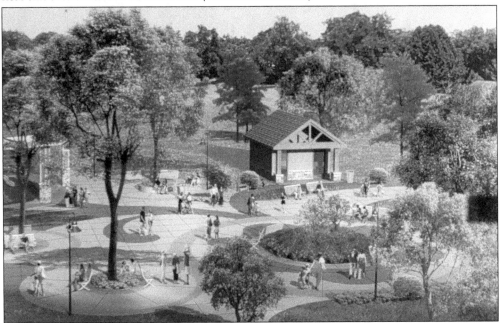

This rendition of what the park is expected to look like has some similarity to what people once experienced at LeSourdsville Lake and Americana Amusement Park. The park had a unique atmosphere and quirky surroundings that will be partially captured in the new recreational park. Memories of LeSourdsville Lake and Americana will live on in the hearts and minds of guests. (Author's collection.)

# DISCOVER THOUSANDS OF LOCAL HISTORY BOOKS FEATURING MILLIONS OF VINTAGE IMAGES

Arcadia Publishing, the leading local history publisher in the United States, is committed to making history accessible and meaningful through publishing books that celebrate and preserve the heritage of America's people and places.

Find more books like this at
**www.arcadiapublishing.com**

Search for your hometown history, your old stomping grounds, and even your favorite sports team.

CPSIA information can be obtained
at www.ICGtesting.com
Printed in the USA
BVHW051654060522
636306BV00003B/166